IMAGES
of America

MT. ANGEL

ON THE COVER: The Mt. Angel Post Office was most likely a central delivery point for the Southern Pacific Railroad and also the main shipping point for towns east of the city. Thomas Ambler, the 1909 postmaster, noted on the back of this photograph that 203,191 pounds of mail passed through the post office that year. Ambler owned the building, and receipts show that he charged the government $120 a year for the rent. (Courtesy of Mt. Angel Historical Society.)

Sandra Graham and Bonita Anderson

Copyright © 2012 by Sandra Graham and Bonita Anderson
ISBN 978-0-7385-9333-3

Published by Arcadia Publishing
Charleston, South Carolina

Printed in the United States of America

Library of Congress Control Number: 2012934127

For all general information, please contact Arcadia Publishing:
Telephone 843-853-2070
Fax 843-853-0044
E-mail sales@arcadiapublishing.com
For customer service and orders:
Toll-Free 1-888-313-2665

Visit us on the Internet at www.arcadiapublishing.com

To the community of Mt. Angel

—Sandra Graham

*To my community, connected by blood or choice,
thank you for sharing the journey.*

—Bonita Anderson

Contents

Acknowledgments 6

Introduction 7

1. Early Settlement 9
2. Changing Architecture 29
3. Business and Industry 47
4. Spirit of Faith 63
5. An Emphasis on Education 81
6. Celebrations and Entertainment 95
7. Faces of the Community 111

Bibliography 127

Acknowledgments

The love of history is alive and well in Mt. Angel, Oregon, and many descendants of early settlers still live and work in the community. Every year, they still celebrate the bounty of the earth and the goodness of creation, but they have turned it into one of the best festivals in the state of Oregon—Oktoberfest. The festival is the perfect example of local people getting involved and working together to create something great.

Since Bill Predeek was a child, he was fascinated with his hometown, where his family had lived for generations. He started gathering stories and photographs. Meanwhile, Sr. Alberta Dieker was caring for the archives of the Queen of Angels Monastery and had written a book on the history of the Benedictine Sisters in Mt. Angel. On the butte where the Mount Angel Abbey sits, Brother Cyril Drnjevic was also involved with the archives of the Benedictine monks. Several years ago, the three historians got together and created the Mt. Angel Historical Society.

These three people were invaluable as we wrote this book. They gave of their time, their stories, and most of all, they passed on their love of the community to us. We are so grateful to Bill Predeek, Sr. Alberta Dieker, and Brother Cyril Drnjevic—there are not words enough to communicate our thanks.

We appreciate the help of the members of Trinity Lutheran Church and Rev. Tom Arnold and their willingness to share stories and photographs.

We also want to thank the residents of Mount Angel Towers, who dropped by to help us identify people and to share their photographs. Several grandmothers brought the latest generation of the original settlers to meet us. Now that was exciting!

We also want to thank our editor at Arcadia Publishing, Elizabeth Bray.

Most of the photographs are attributable to Mt. Angel Historical Society (MAHS), Queen of Angel Monastery Archives (QAMA), Mount Angel Abbey Archives (MAAA), and Trinity Lutheran Church (TLC).

Introduction

Mt. Angel is located in the northeastern Willamette Valley along the foothills of the Cascade Range. In the early days, the town was known by three different names: Frankfort, Fillmore, and Roy. The town's current name was suggested by Fr. Adelhelm Odermatt in 1883. Father Odermatt came from Engelberg, Switzerland, and founded Mount Angel Abbey. He suggested translating Engelberg from German to the English—Mt. Angel. The Willamette Valley's rich soil and mild climate drew immigrants to the Oregon Territory, and Mt. Angel is still surrounded by farms and nurseries. The scenic Silver Falls State Parks and the snow-capped beauty of Mt. Hood are both close to town.

The Kalapuyan Indians lived in the Willamette Valley in the warm seasons, hunting local game and gathering local plants, particularly the Camus root, which was used for both food and trade. During their travels through the Willamette Valley, they would go to the top of Lone Butte, which they called Tapalamaho, or "Mount of Communion." The Kalapuyan placed stones strategically at the top of the butte to sit and communicate with the spirits.

After the US government sponsored the Donation Land Claim Act in 1850, the Oregon Territory underwent major changes. The act encouraged expansion, giving 320 acres to any man 18 or older who lived in the Oregon Territory before December 1850. If they were married, they got 640 acres. Benjamin Cleaver, a native of Kentucky, crossed the plains to the Oregon Territory with his wife, Rachel, and their 10 children, selecting a claim in the fall of 1850. A large portion of Cleaver's claim is now Mt. Angel. Other immigrants staking land claims around the Lone Butte at that time included George Settlemier, William Glover, Samuel Tucker, and Robert Milster. In 1854, the Lone Butte School began its first session, with William Cline as the first teacher. It was located on the southwest side of the Butte, and 57 children were enrolled.

By 1855, the Kalapuyan and other tribes of the Willamette Valley had ceded their lands through treaties, and most of the Kalapuyan Indians had been removed to the Grand Ronde Reservation.

The Willamette Valley's crops consisted of fruit, oats, and wheat. At one time, the Willamette Valley grew half of the hops produced in the United States. During picking season, thousands of people came to the hop fields from all over the state, bringing the whole family, the dog, and everything they would need to live—in a cabin or tent supplied by the grower—for as long as a month. The hop yards became like small towns; most had a camp store, a deputy sheriff to keep order, and a place for homegrown entertainment like boxing matches and Saturday night dances. Friendships were made, and the hop yards were often the site of summer romances, some leading to marriage.

While agriculture is a significant part of the history of Mt. Angel, extra crops and the need for economic development led to the building of a railroad. In 1877, a narrow-gauge railroad was initiated, and by 1881, the tracks had reached 183 miles. The first business building in Mt. Angel was the flag station for the railroad, followed shortly by the post office. The railroad offered

opportunities for people and businesses to come to Mt. Angel, leading the community's growth. In 1893, the town was incorporated and a city council was established, and every year after brought additional infrastructure and business to support the community. In 1905, the Oregon State Legislature officially incorporated the City of Mt. Angel. The first mayor was Fred Schwab, who had served as president of the city council from its inception.

Faith was an integral part of life for the early settlers. The first church was built near Abiqua Creek on the land claim of Samuel Allen in 1850. Everyone was welcomed to the church regardless of faith. In the 1880s, Rev. Ed Doering, one of the first Lutheran pastors in the state, traveled from Portland to Mt. Angel to provide services for the growing Lutheran community.

In 1882, Fr. Adelhelm Odermatt and the Benedictine Sisters from Switzerland established an education and spiritual presence. The Benedictine Sisters built a monastery, provided education, opened a nursing facility, and provided services for refugees, migrant workers, and the homeless. The Benedictine monks at Mount Angel Abbey built a monastery, founded a college, constructed a seminary, and since 1881 have provided services to the local parish community.

In the early 1970s, the town also supported a small liberal arts college, the Colegio Cesar Chavez, named after civil rights activist Cesar Estrada Chavez, for students of Mexican American heritage. The school was noted for its independent thinking, which inspired students to gain firsthand experience in the community and in informal classrooms.

In the early 1900s, annual fairs drew many participants for horse shows, ball games, and craft fairs. In 1966, the City of Mt. Angel began holding an Oktoberfest celebration featuring traditional German dancing, music, food, drink, and activities for all ages. This annual event currently attracts over 300,000 visitors and is one of the largest festivals in Oregon. Also, Mount Angel Abbey hosts an annual Festival of Arts and Wine and the Bach Classic Music Festival.

Even though the community is small, Mt. Angel is set apart from other small, rural communities, emphasizing and advocating educational opportunities for students of all ages and grades whether in a parochial or public school setting. The city is also a religious center, offering spiritual support and focusing on both local and global needs regardless of religious affiliation.

One

EARLY SETTLEMENT

In the mid-Willamette Valley 18 miles northeast of Salem, a 300-foot butte was known by early pioneers as Lone Butte. Later, some called it Graves Butte because in 1849 John Graves acquired a land claim that took up a large portion of the butte. Because of the rainy climate of the Willamette Valley, road travel was impassable by wagon and the need for a railroad was vital for this community's economic growth. A railway stop was lobbied for and constructed near the butte in 1880 and given the name of Filmore.

With the final construction of the railway in 1881, George Settlemier, who had settled near the Butte in 1850, laid aside a portion of his claim for the construction of a town near the railroad stop. Settlemier named this town Frankfort, and it initially contained 13 blocks and 10 streets. Five of these streets ran parallel to the rail tracks, and six were set at a right angle. In 1882, Settlemier deeded the town of Frankfort to Benjamin Cleaver for $480. Cleaver changed the town's name to Roy. In 1881, Fr. Adelhelm Odermatt, a Benedictine priest who had traveled from Engelberg, Switzerland, chose the Lone Butte area as the future site for his monastic community and suggested changing the name to the anglicized form of Engelberg—Mt. Angel.

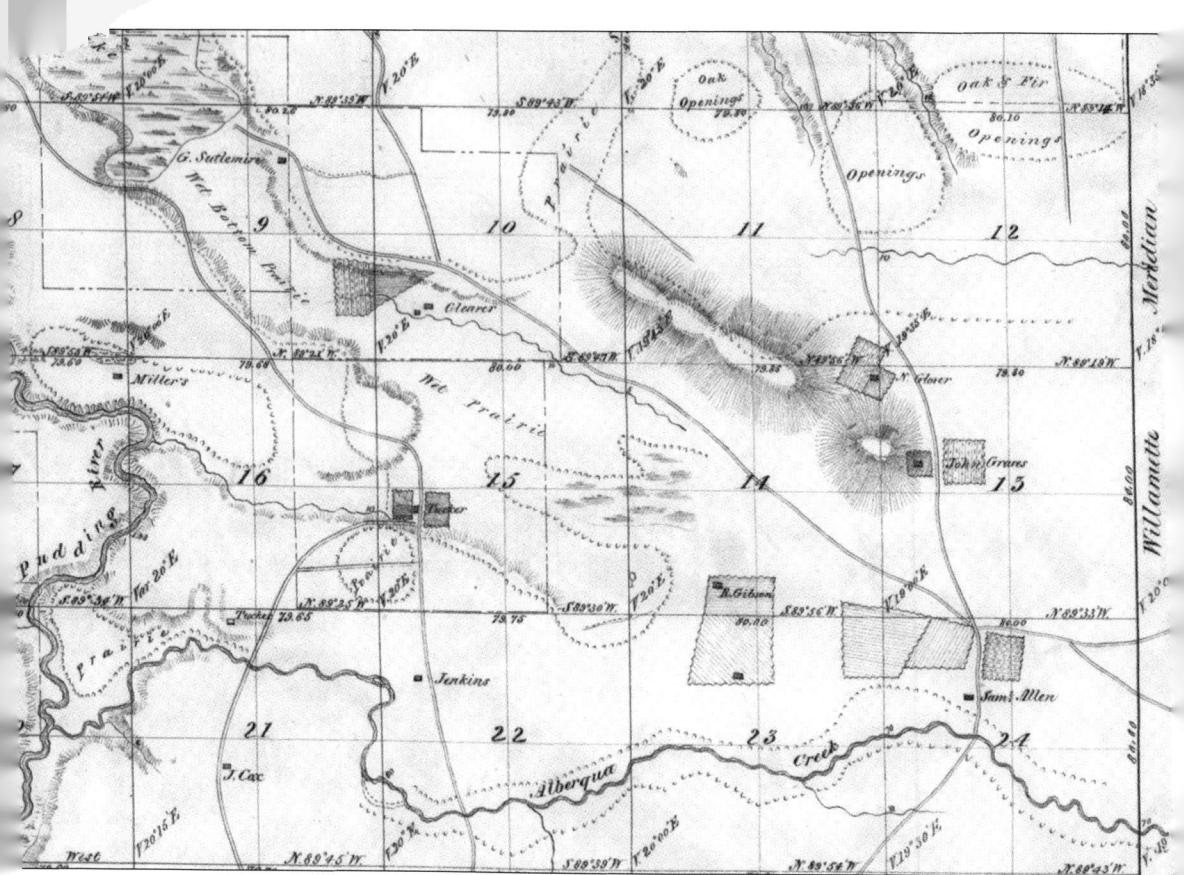

This 1852 Bureau of Land Management survey map of "Township 6 South, Range 1 West" in the Oregon Territory shows the land claims of many of the first settlers near Lone Butte. Randolph Gibson and Samuel Miller purchased claims south of the butte and north of Abiqua Creek. John Grave's claim lies directly east of the butte, while William Glover's land is positioned in the north and Benjamin Cleaver's claim is west of the butte and east of the Pudding River. Samuel Tucker settled just south of Cleaver in section 15. (Courtesy of MAHS.)

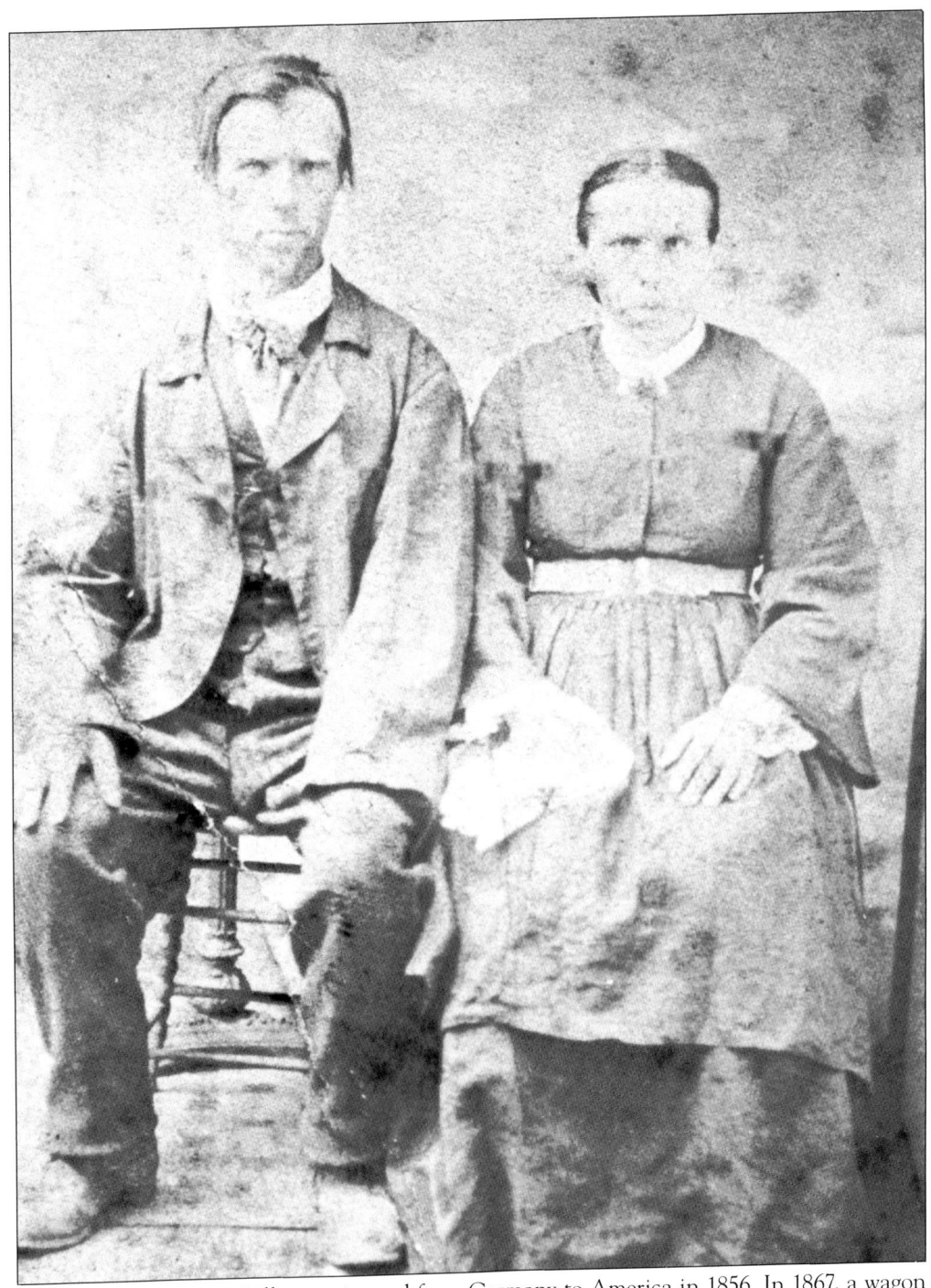

Robert and Katharina Zollner emigrated from Germany to America in 1856. In 1867, a wagon train brought them and their four children to Oregon, where they homesteaded a claim next to a creek just north of the butte. Zollner, along with other early pioneers Louis Schwab and Matthias Butsch, were instrumental in obtaining funds to purchase land for the Benedictine Fathers in 1881. (Courtesy of MAHS.)

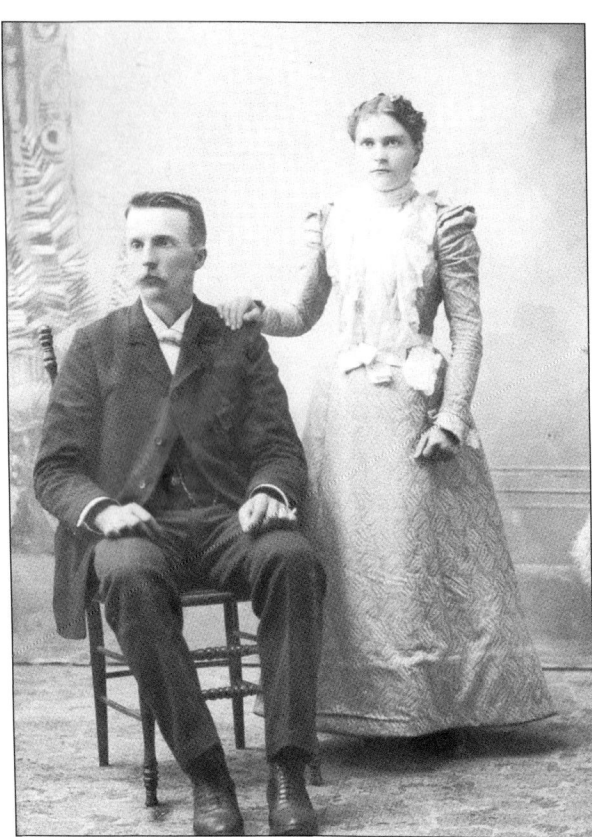

This photograph shows Frank and Bertie Zollner in the 1890s. Frank, the son of founding father Robert Zollner, worked as a traveling salesman and was one of the original members of the Mt. Angel Band. (Courtesy of MAHS.)

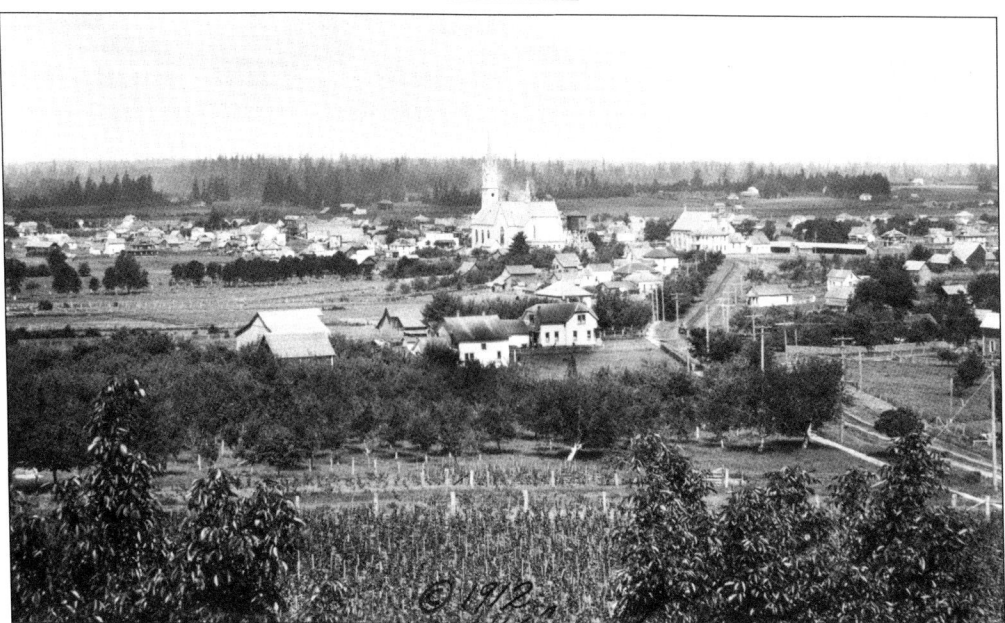

This 1912 view looking west from the foot of the butte shows the newly built St. Mary's Catholic Church. St. Mary's School, built in 1901, sits to the right of the church. The road along the right side of the photograph leads up towards the butte and Mount Angel Abbey. (Courtesy of MAHS.)

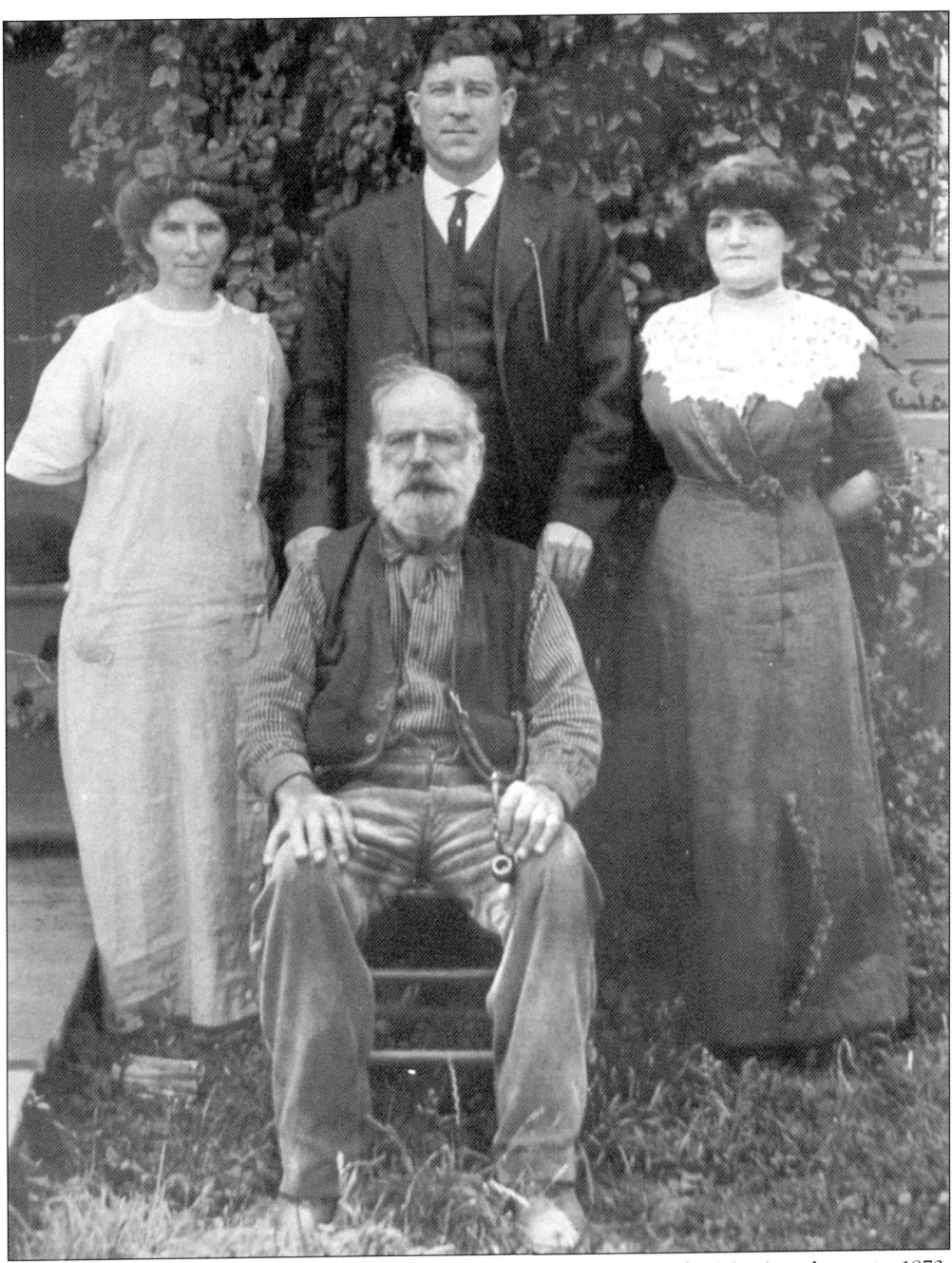

Thomas Fuchs emigrated from Einsiedeln, Switzerland, settling in the Mt. Angel area in 1873. Fuchs ran a harness and saddle shop in town and raised cattle on his farm. Some historians claim that he may have known Father Odermatt while living in Switzerland. In his later years, Fuchs spent much of his time helping the Benedictine Fathers on their farm. Here, Fuchs (sitting) poses with three unidentified family members in the 1920s. (Courtesy of MAHS.)

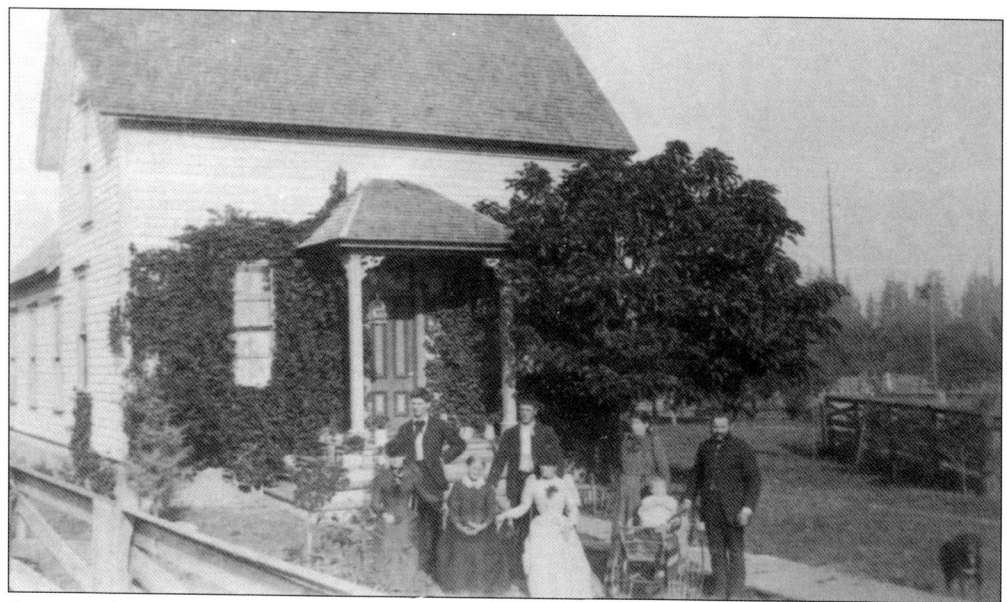

Anna Fuchs, Thomas's wife, sits in the center of this photograph with unidentified family members in front of their house. (Courtesy of MAHS.)

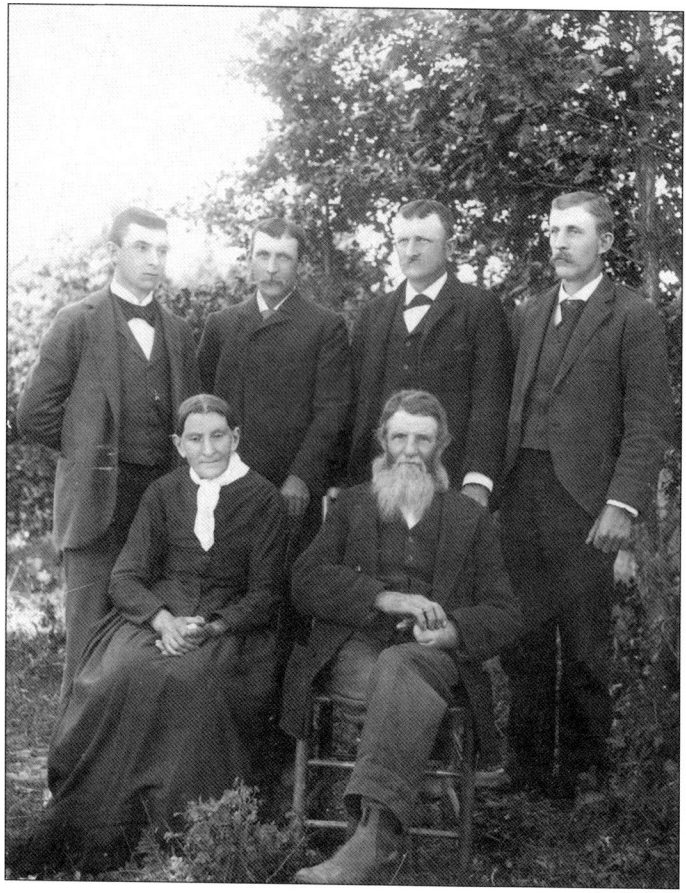

Fred and Fredrica Schmelzer (sitting) came west in 1876, purchasing 320 acres just east of present-day Mt. Angel from Robert Milster. In 1890, Fredrica was influential in the organization of the Lutheran congregation and advocated for the need of a minister to permanently reside in the Lone Butte area. Their sons are, from left to right, (standing) Henry, Herman, Fritz, and Charles. (Courtesy of TLC.)

Mathias Butsch settled in the Lone Butte area with his family in 1878. Butsch donated lumber from his sawmill for the building of St. Mary's Catholic Church and wrote to Eastern newspapers encouraging people to move out west because of the Willamette Valley's mild climate and the proposed monastery. (Courtesy of MAAA.)

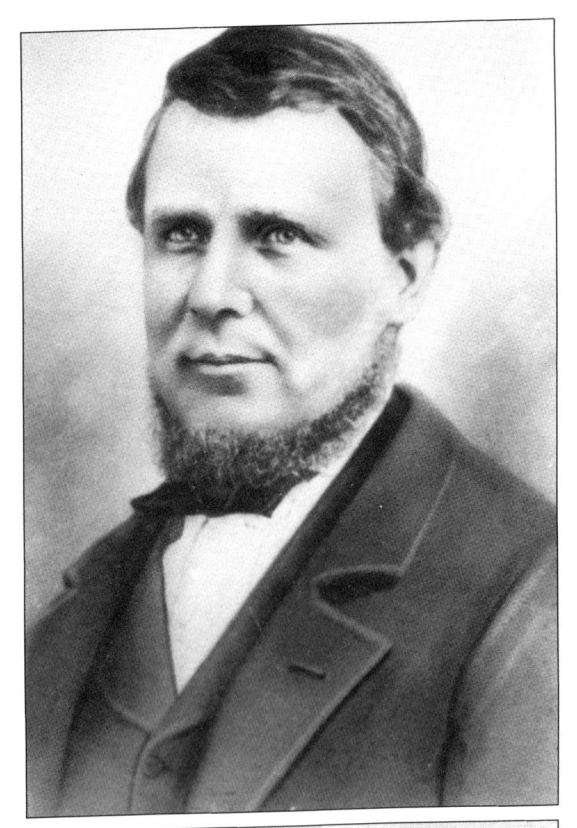

Archbishop Charles Jean Seghers, who presided over the Roman Catholic community in Oregon from 1880 to 1885, wrote a letter to Mathias Butsch in September 1881 telling him to expect a visit from two Benedictine priests, Fr. Adelhelm Odermatt and Fr. Nicholas Frei, who had traveled from Switzerland to the western United States in search of a new monastery location. (Courtesy of MAAA.)

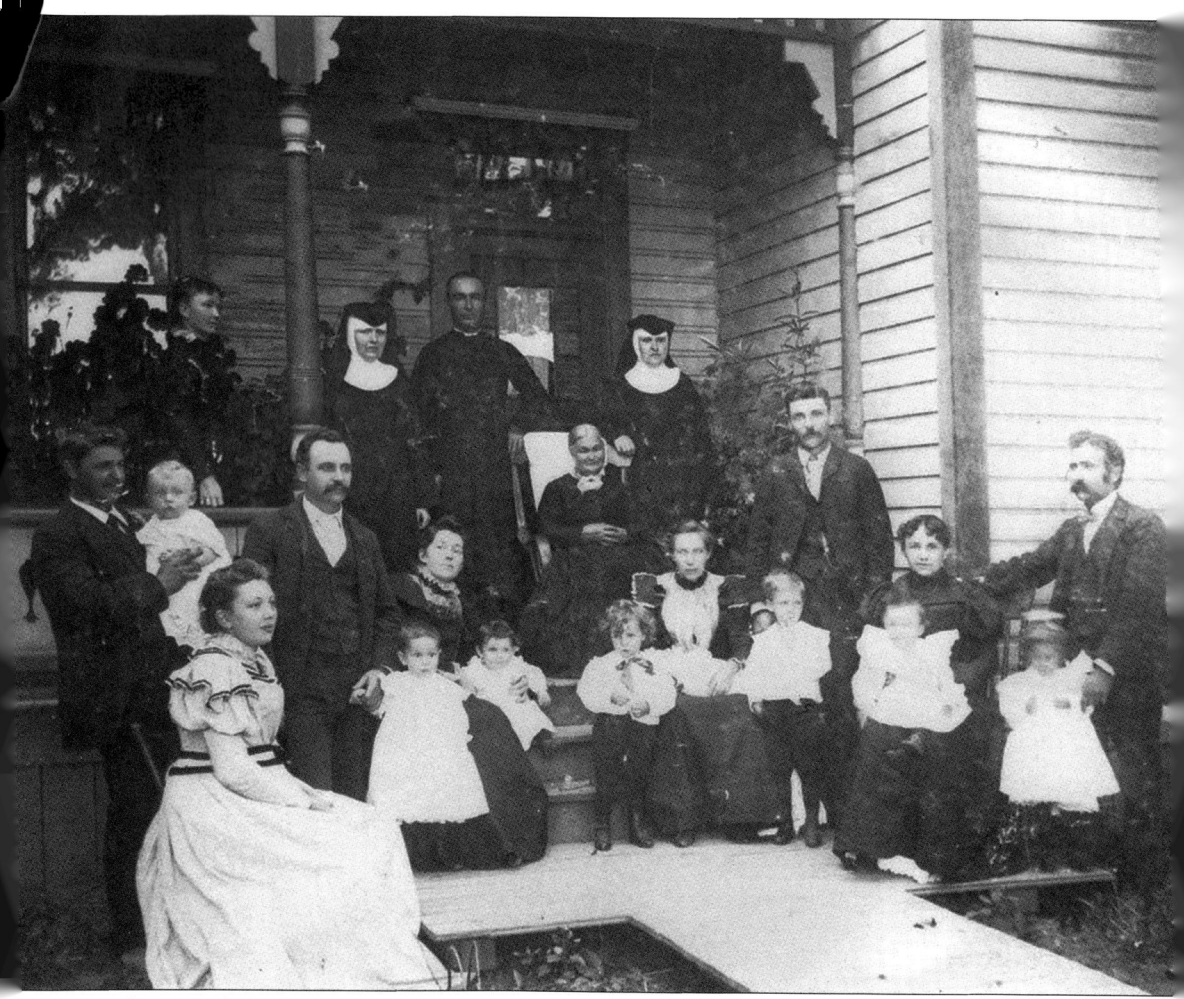

The Butsch family was photographed here almost five years after Mathias's death in the late 1800s. Agatha Kribs Butsch, Mathias's widow, sits on the porch. Standing behind Agatha to her right is her daughter, Sr. Wilhelmina Butsch. To Agatha's left are her eldest son, Fr. Joseph Butsch, and her daughter, Sr. Agnes Butsch. Henry Butsch and his wife, Rose, are on the far right. (Courtesy of MAHS.)

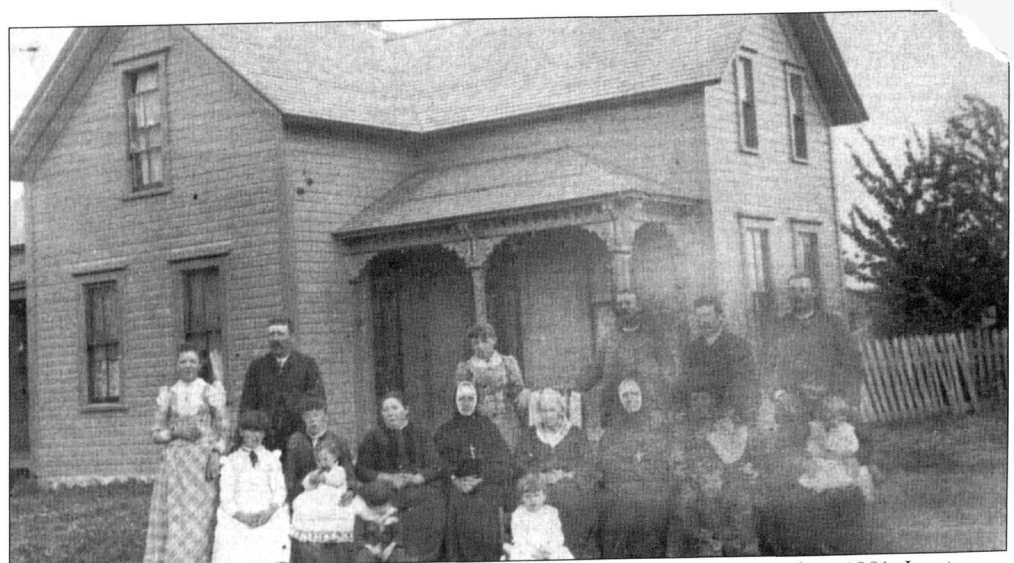

Louis Schwab and his wife, Josephine, took up a land claim in Mt. Angel in 1881. Louis was instrumental in purchasing land for the Benedictine Fathers in the early 1880s but died in 1882 before the land transaction was completed. His family continued his cause, helping the Benedictine settle in Mt. Angel. Here, Josephine sits between two of her daughters, Sr. Caroline Gaudentia and Sr. Dorothea Rosula. The rest of the family is unidentified. (Courtesy of MAHS.)

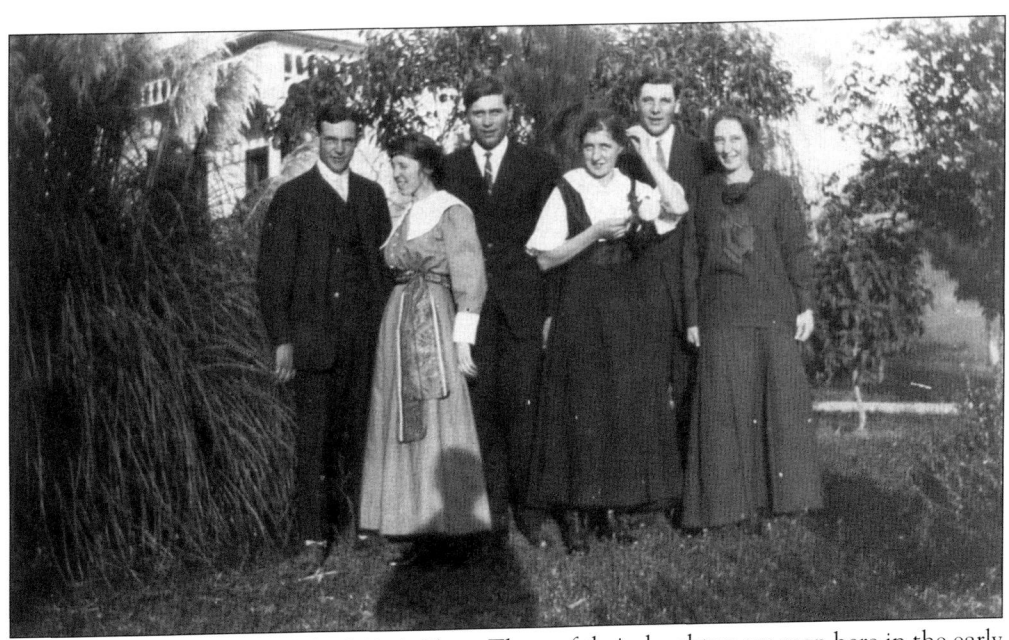

Louis and Josephine Schwab had 11 children. Three of their daughters are seen here in the early 1920s. From left to right, they are Josephine, Teresa, and Margaret. Standing behind them are Albert Bourbonnais and John and Frank Schwab, sons of Adolph Schwab and first cousins of the girls. (Courtesy of MAHS.)

17

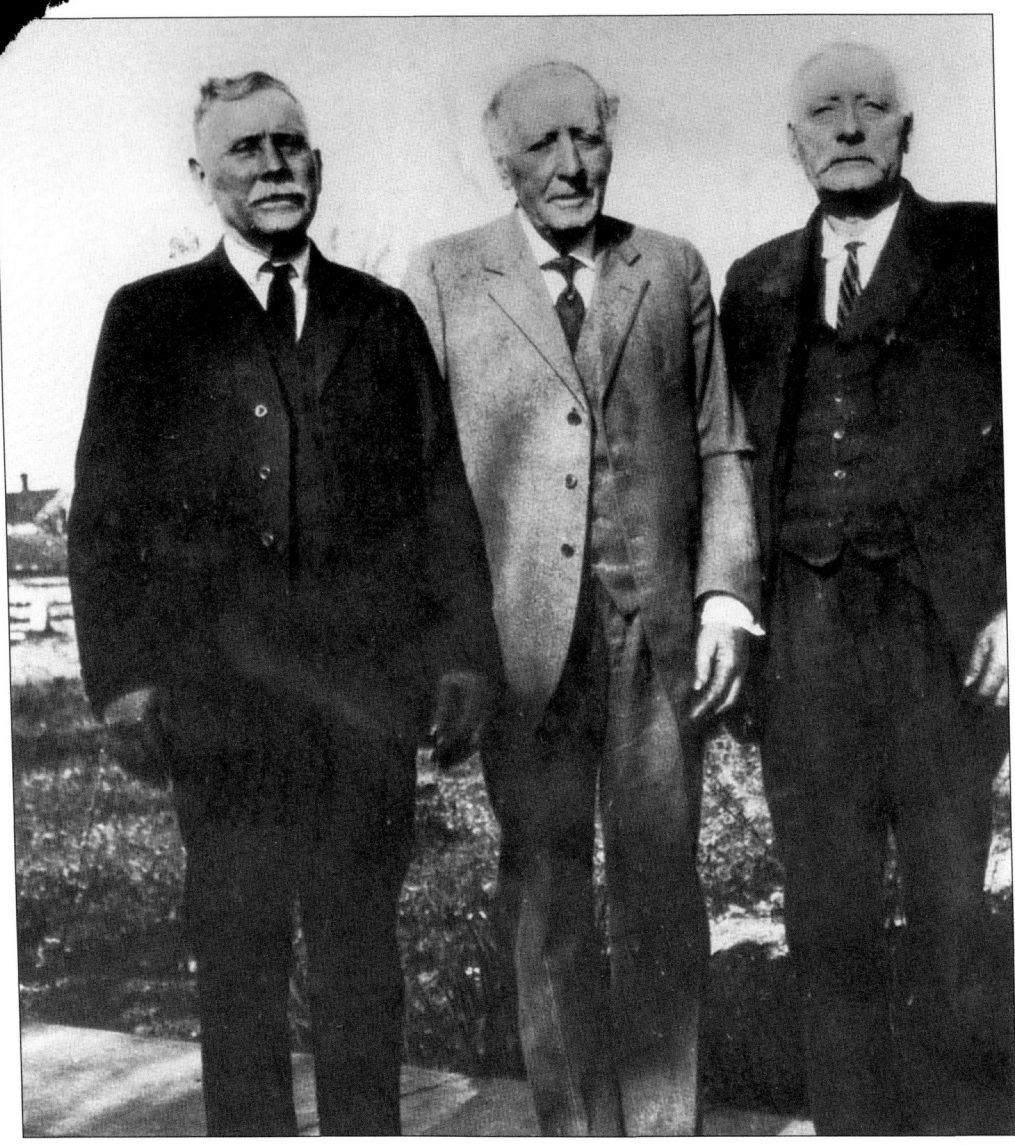
From left to right, Fred, John, and Adolf Schwab pose together in the 1920s. Fred Schwab was Mt. Angel's first mayor, from 1902 to 1911, and served again from 1920 to 1922. With the help of Fr. Barnabas Held, who provided the musical instruments, they organized a community band in the 1880s, playing at major venues throughout the state. (Courtesy of MAHS.)

George Mickel, a German immigrant, brought his family to the Lone Butte area in 1869. Mickel's son Nicolas and his wife, Anna (Koler), were the first farmers to raise hops in the area. The Nicolas Mickel family is shown here, from left to right, (first row) Nicolas Mickel, Margaret, and Anna; (second row) Marie, Nicholas George, and Mary Ann. (Courtesy of MAHS.)

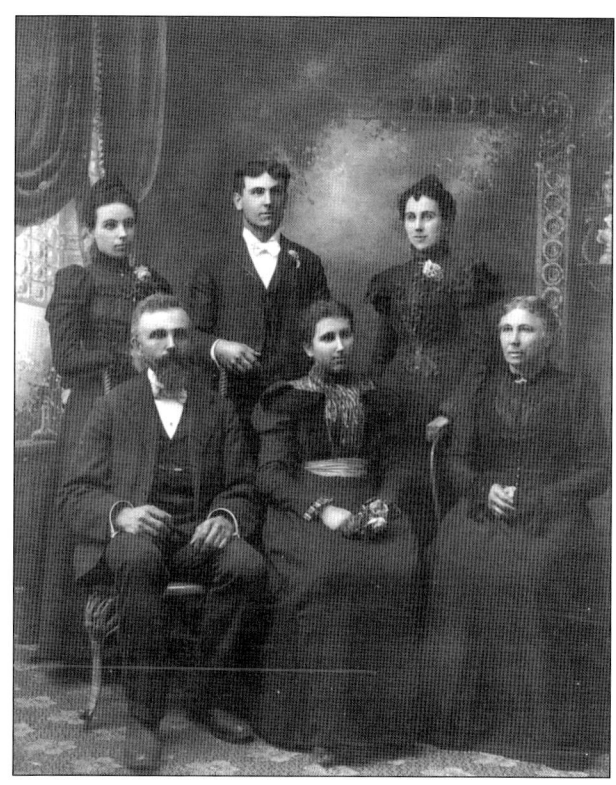

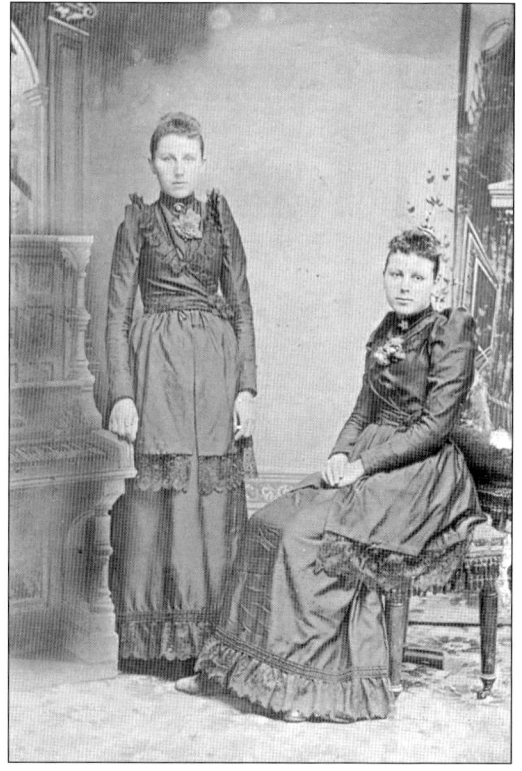

This photograph of Mary and Annie Mickel was taken around 1880 by the William Jones Photography Company. Jones, an immigrant from Wales, lived four miles south of Mt. Angel in Silverton and traveled around the state with his tent and photography equipment to expand his business. (Jones photograph; courtesy of MAHS.)

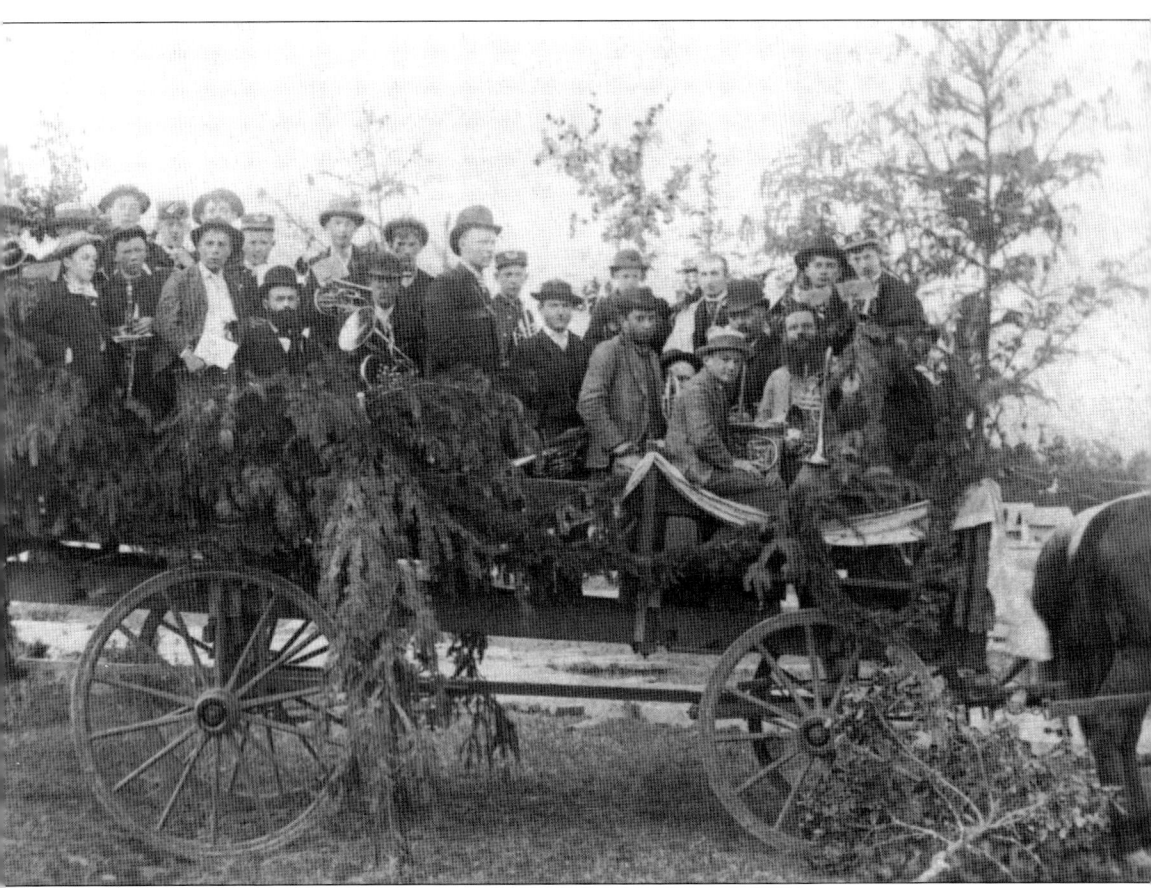

The Mt. Angel Band is seen here around 1890. An extension was built on the back of the wagon in order to fit all the band members. The band was requested to play at local dances, church functions, and large events such as the Oregon State Fair in Salem. Some of the original band members were John, Henry, and Joe Butsch; Adolf and Fred Schwab; Frank and Joe Zollner; Joe Bucheit; Al Klein; Theodore Stravens; Chris, Paul and John Fuchs; and Mark and Jack Fessler. (Courtesy of MAHS.)

```
                    Roy, Marion County, Oregon
                      Established February 1, 1882

  Name of Postmaster                                    Appointed

  Monroe Cleaver                                        Feb. 1, 1882

  Name of office changed to Mount Angel Sept. 19, 1883

  Peter W. Ness                                         July 13, 1892
  Daniel Friedmann                                      June 6, 1893
  John W. Ebner                                         March 7, 1895
  Thomas L. Ambler                                      April 4, 1898
  Gaphart D. Ebner                                      Jan. 30, 1915
  Leonard A. Fickert - act                              July-1-1948
  Leonard A Fickn - permanent                           June-10-1949
```

Mail delivery in the 1850s cost 25¢ plus 3¢ for postage. At first, the Adams, Todd, and Wells Fargo Express Company delivered the weekly mail to Samuel Allen's house southeast of the Lone Butte. By 1882, a post office was established at John Palmer's store and Monroe Cleaver was the postmaster. (Courtesy of MAHS.)

Bernard and Mary Anna (Scharbach) Oswald moved to Mt. Angel in the 1880s after reading Mathias Butsch's newspaper article praising the Willamette Valley's climate. Oswald bought a lot in town in 1893 and built the Hotel Mt. Angel on Railroad Avenue. (Courtesy of MAHS.)

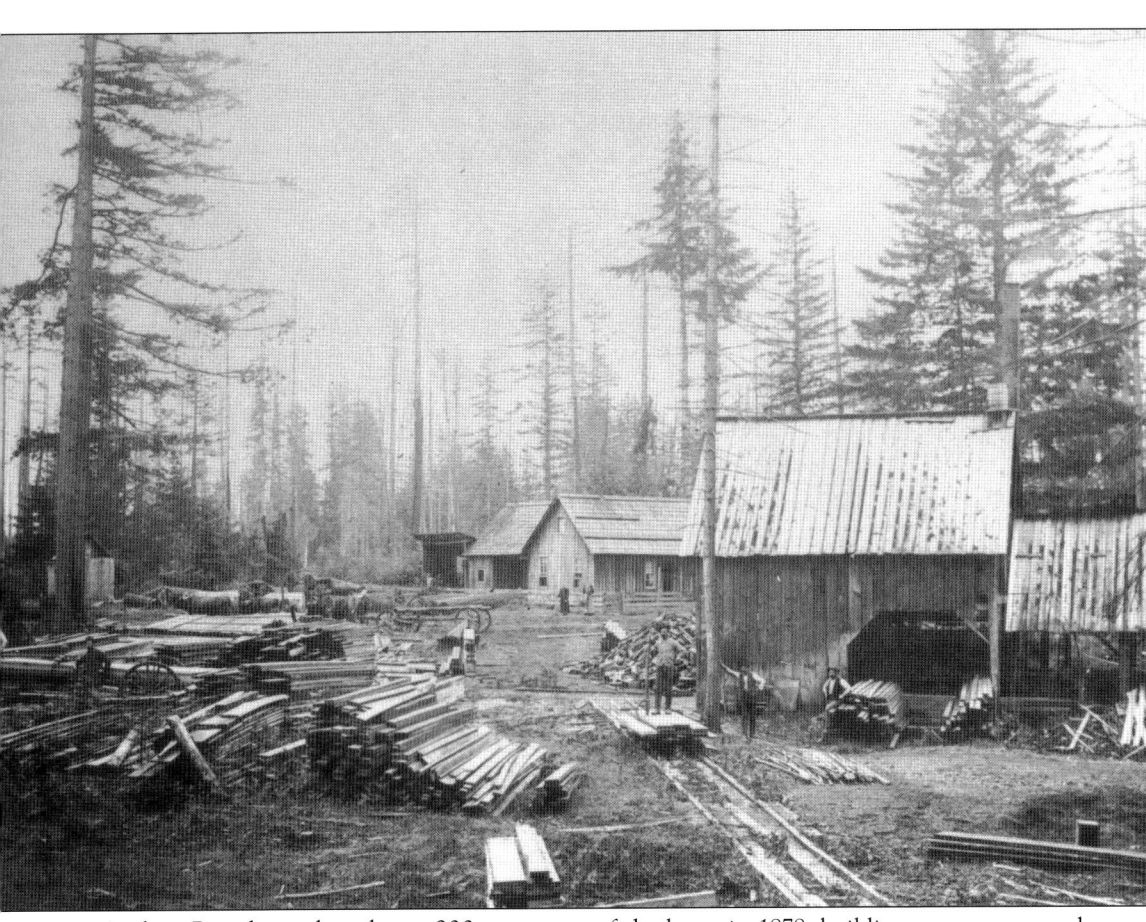

Matthias Butsch purchased over 200 acres west of the butte in 1878, building a water-powered sawmill, which provided lumber for many of the buildings in the area, including donated lumber for the construction of St. Mary's Catholic Church in 1881. (Courtesy of MAHS.)

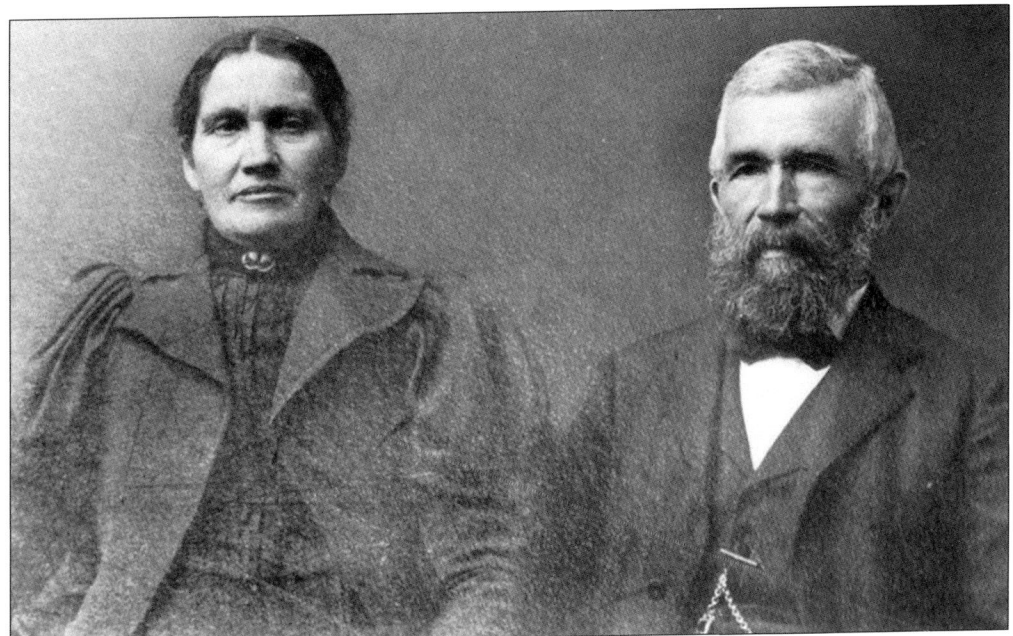

Stephen Fessler was born in Einsiedeln, Switzerland, and immigrated to the United States in 1860 with his brothers Meinrad and Joseph. In 1872, all three moved with their families to Mt. Angel. Stephen operated a farm just outside of Mt. Angel and was survived by his wife, Barbara, seen here in 1898 with her second husband, Peter Villiger. (Courtesy of MAHS.)

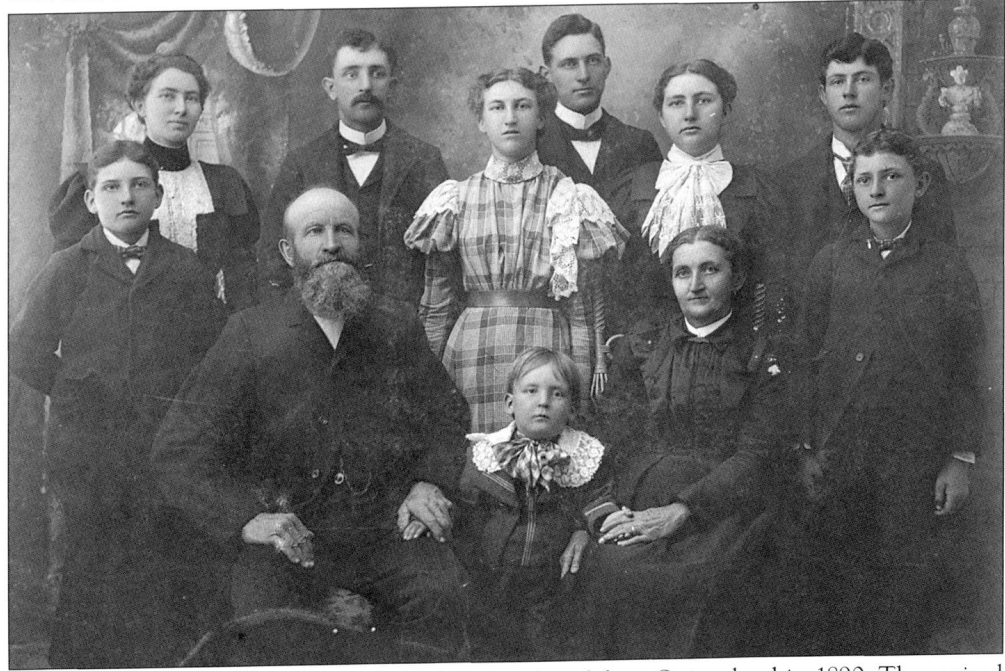

Joseph and Anna Marie Bochsler moved to Mt. Angel from Switzerland in 1890. They raised hops and operated a dairy farm, and Joseph helped construct St. Mary's Catholic Church in 1912. Their children were, in no particular order, Joseph, Maria Elizabeth, Caroline, Josephina, Charles, Ida Mary, Albert, and Emil. (Nancy Bochsler photograph; courtesy of MAHS.)

Emil Bochsler, Joseph's youngest son, worked the family farm with his brothers Charles and Albert before purchasing a hardware store in town and marrying Josephine Beyer in 1928. (Sue Kloft photograph; courtesy of MAHS.)

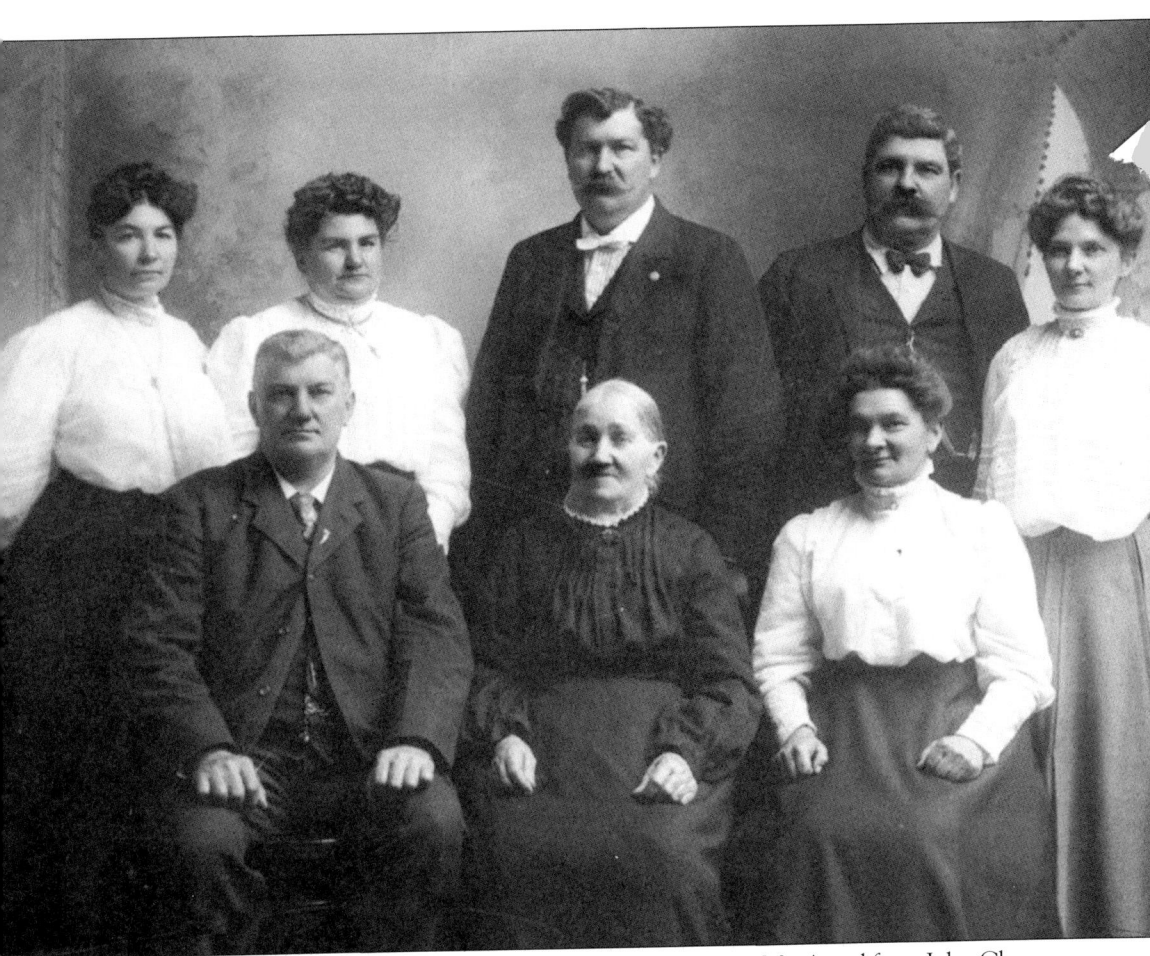

In 1876, Joseph and Appolonia Scharbach purchased 340 acres near Mt. Angel from John Cleaver. They grew wheat and oats and cultivated fruit trees. Joseph donated land for Mt. Angel's first Catholic church and the cemetery. Appolonia is seen here with many of her adult children in the 1890s. They are, from left to right, (first row) Theodore, Grandma Appolonia, and Appolonia; (second row) Mary, Christina, Alex, Jacob, and Frances. (Courtesy of MAHS.)

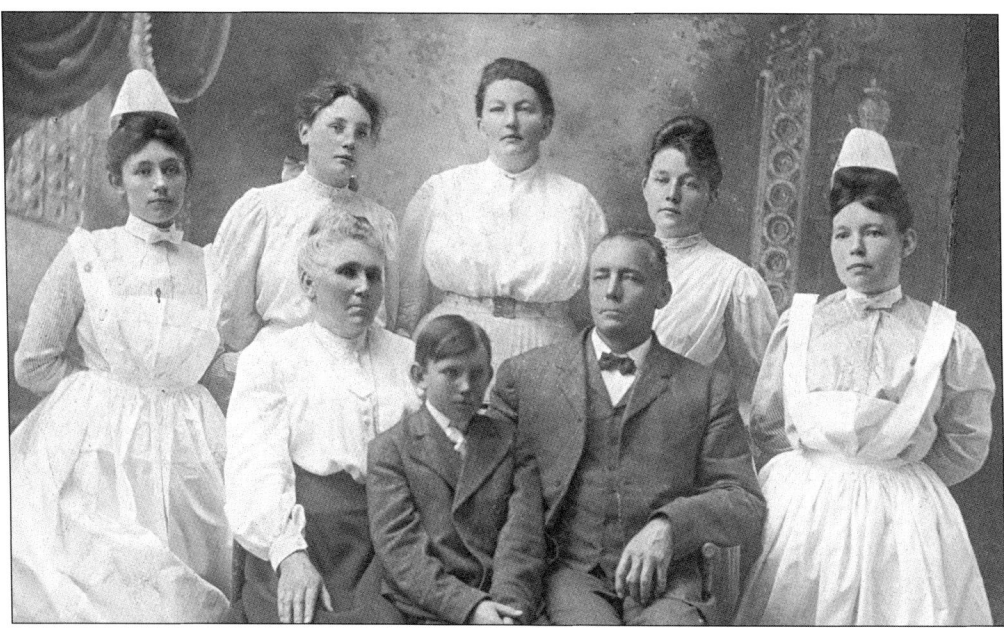

Joseph Scharbach's son Peter is seen here in 1910 with his wife, Margaret. Peter took over the family farm when his mother, Appolonia, was no longer able to care for it. (Courtesy of MAHS.)

David Back settled in the Mt. Angel area in the 1880s and married Christina Von Hatten. In 1900, he built the White Corner store across from St. Mary's Catholic Church. His family included, from left to right, (sitting) Christina, Jack, and David; (standing) Rosalia, Theresa, Maude, Laura, and Antonia. (Kathleen Ebner photograph; courtesy of MAHS.)

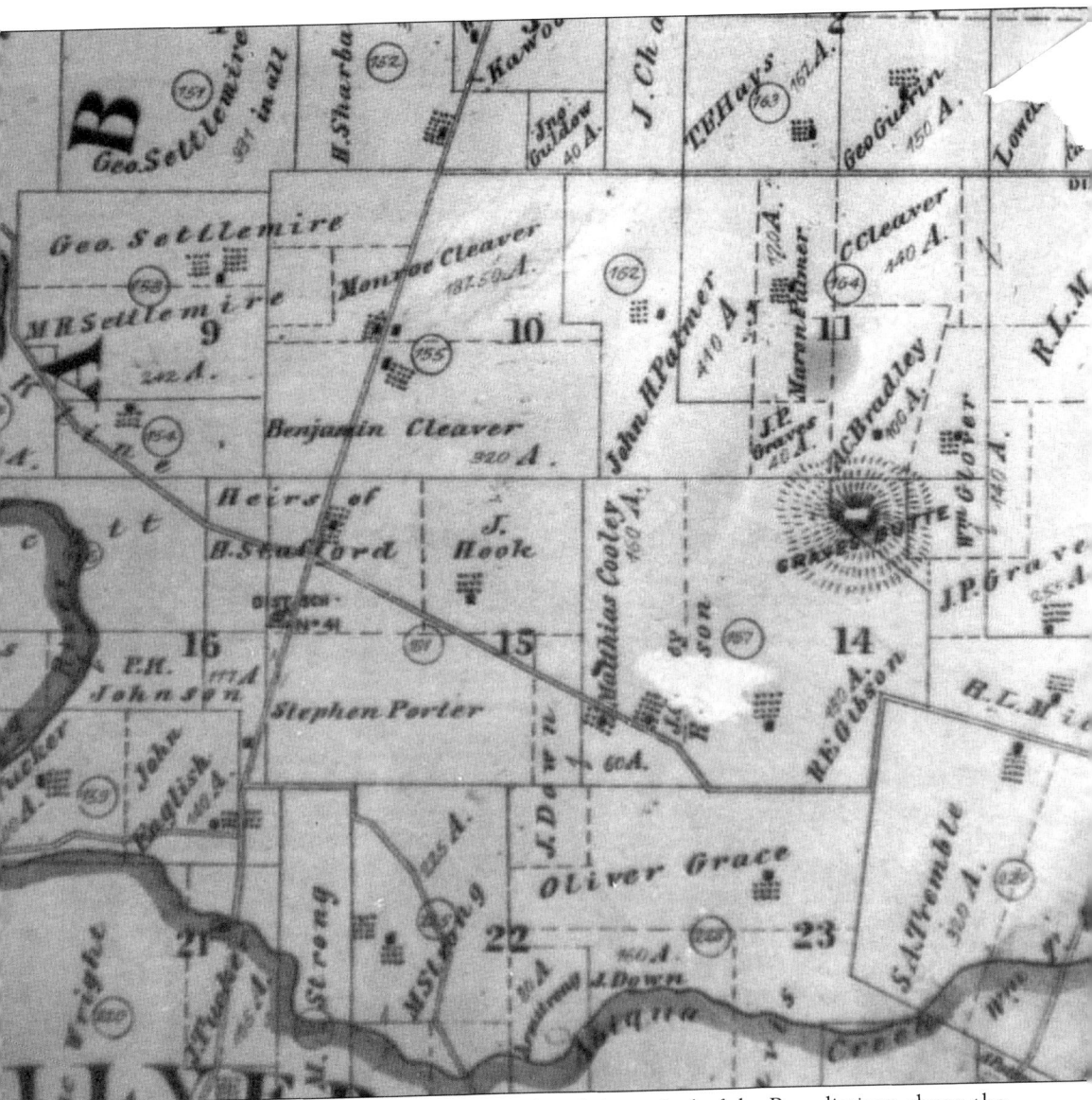

This survey map, most likely drawn before 1880 and the arrival of the Benedictines, shows the community of settlers living around the butte at that time. Note that Lone Butte School District No. 41 lies almost directly west of the butte. (Courtesy of MAHS.)

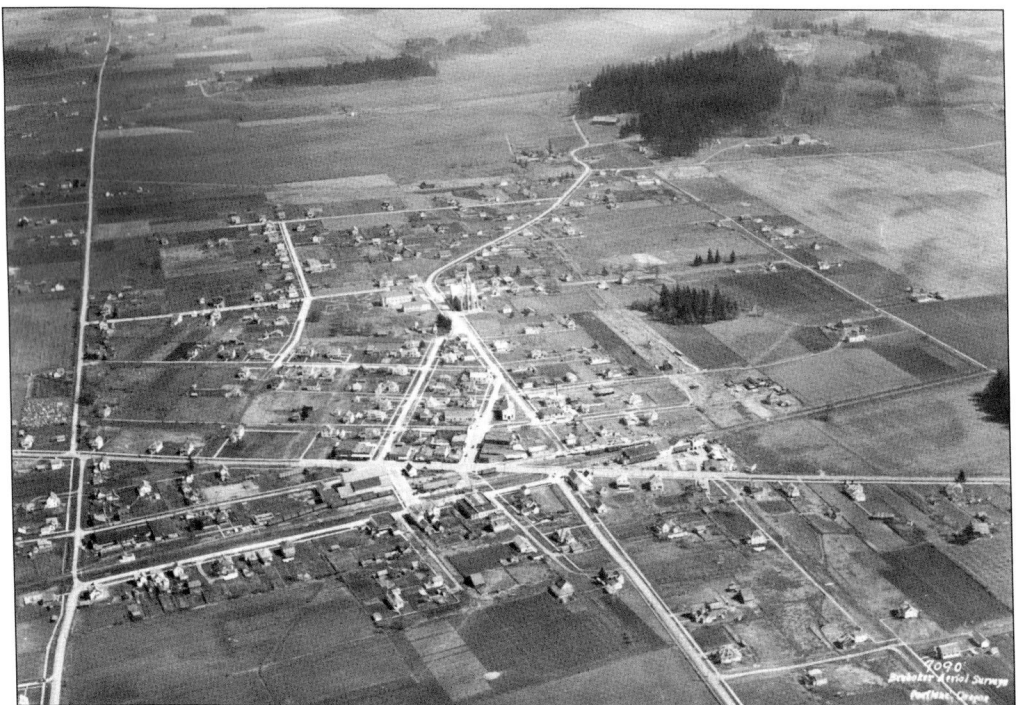

After World War I, aerial surveys of cities were common for military and commercial purposes. This 1927 aerial view, looking west towards Mt. Angel, was taken by the Brubaker Aerial Survey Company. William Brubaker, a pioneer in commercial aerial photography, took thousands of aerial photographs for civic and government agencies during this time. (Brubaker Aerial Survey photograph; courtesy of MAHS.)

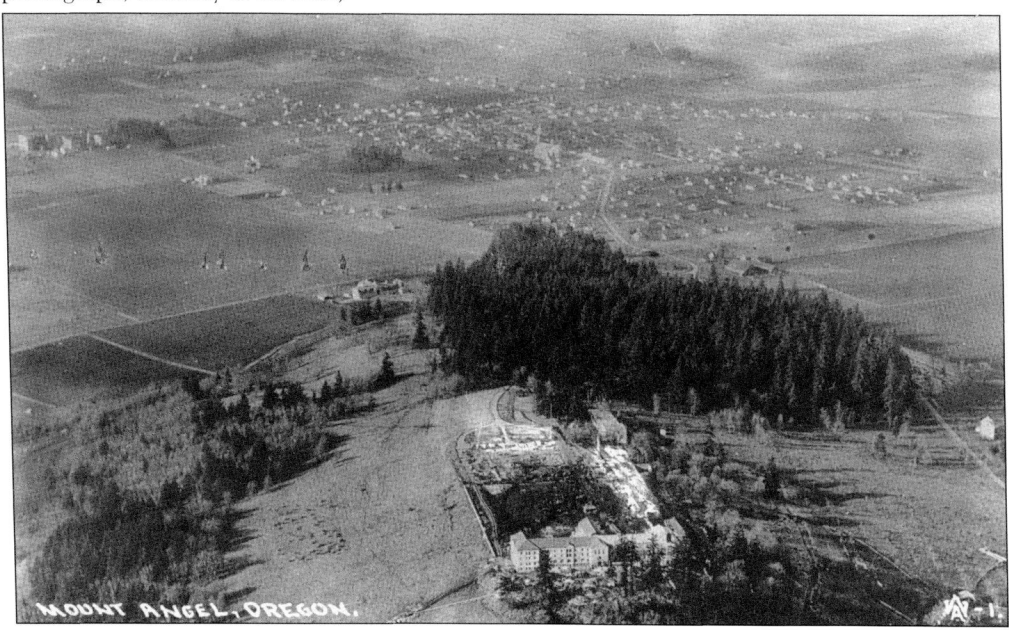

This 1927 aerial photograph looks west towards the city of Mt. Angel with Mount Angel Abbey on the butte in the foreground. (Brubaker Aerial Survey photograph; courtesy of MAAA.)

Two

Changing Architecture

When George Settlemier sold land back to Benjamin Cleaver in 1882, Cleaver renamed the town Roy and entrusted the streets and highways for public use in perpetuity.

In 1893, an act to incorporate was filed for the town of Mt. Angel and a council was created with five councilmen: Bernard Oswald, D. Friedman, Joseph Esch, Thomas Palmer, and Monroe Cleaver. Peter W. Mess was recorder, Mathias Butala was treasurer, and Edward Cunningham was town marshal. With the backing of the 25 registered voters in Mt. Angel, this group set about creating the infrastructure of a town.

Between 1893 and 1905, steady progress was made. In the minutes of town meetings during this time, the council required property owners to build sidewalks and businesses to be licensed and allowed the marshal to impound loose animals. The council voted to gravel the streets from funds raised through licenses.

Also during that time, the marshal was responsible for lighting the three streetlamps purchased for the town in 1894 and left on from dusk to 10:00 p.m. In 1902, the first electrical lighting was installed and a 30-year contract was signed.

Fires plagued Mt. Angel, burning Mount Angel Abbey, St. Mary's Church, and the town hall. In a 1905 ordinance, the town council decreed that there would be no more wood-frame buildings in the city park addition facing Charles Street and that all structures must be of brick.

Around that time, the volunteer fire brigade was created, consisting of Jacob Hessel, Paul Fuchs, Anton Poepping, Joseph Zollner, and Laurence Stupfel. Gaphardt Ebner was elected captain of the brigade, and the firehouse was built by local contractor George Zollner.

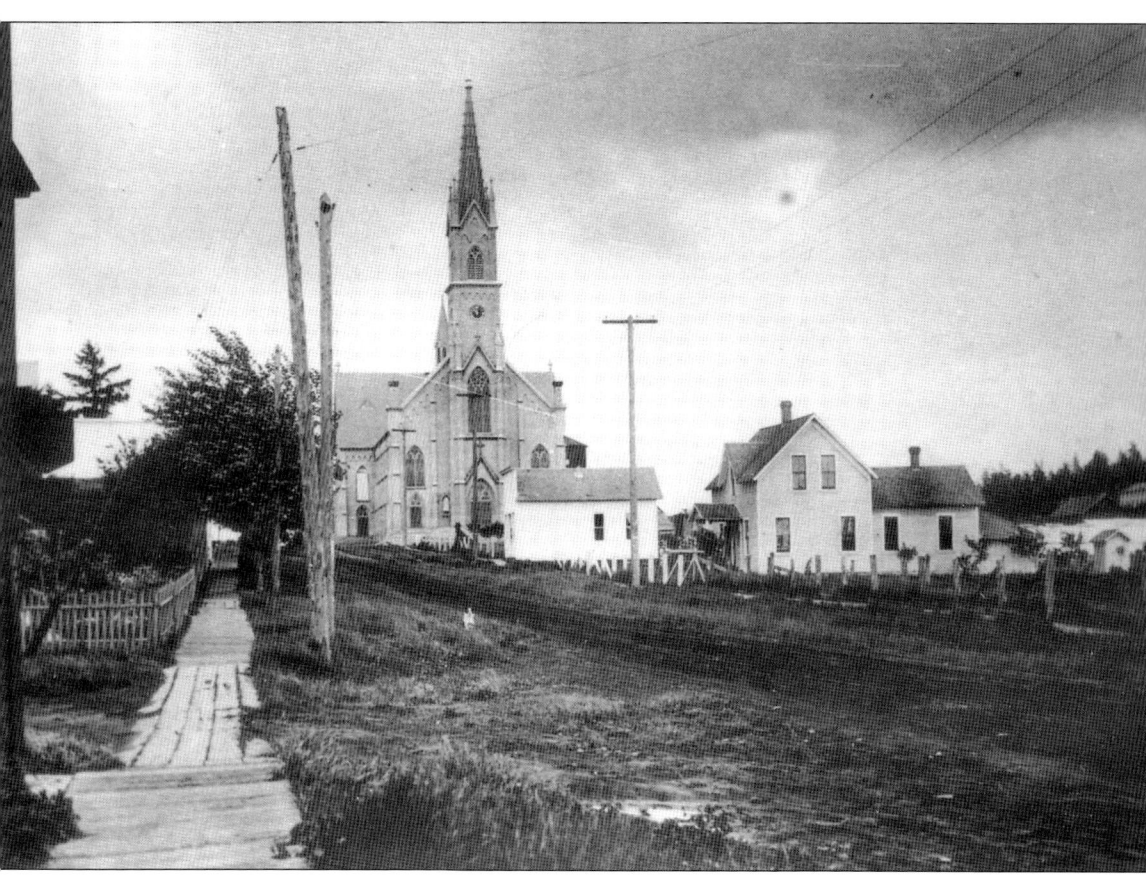
Looking toward St. Mary's on Church Street, the sidewalks are wood and the streets are still difficult to travel in the rainy season. Mt. Angel was a town in transition, with electricity and a major water system helping to expand business. (Courtesy of MAHS.)

St. Mary's Church still defines the look of Mt. Angel. The first church the settlers built could only hold about 200 people, and within three years, they had outgrown it. After the Abbey Church burned in 1892, a new 50-foot-by-100-foot church was built in 1893. (Courtesy of MAHS.)

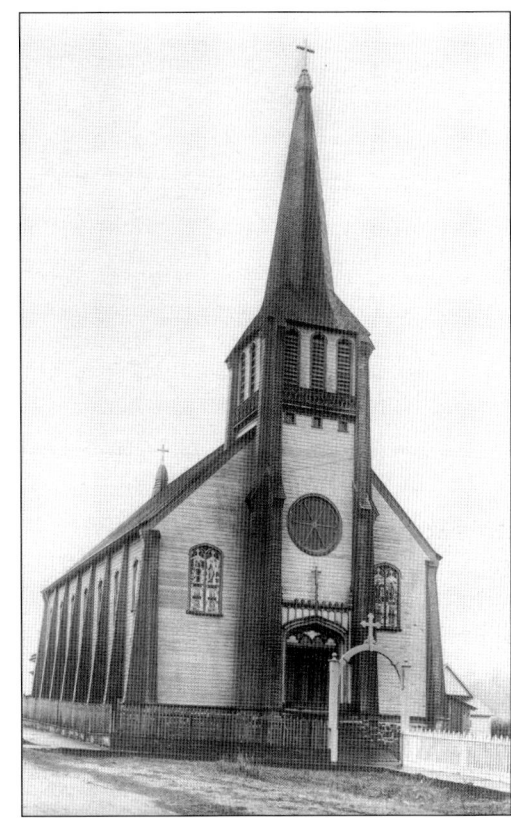

Behind St. Mary's Church is the St. Mary's parish house, built in 1905. The parish had administrative offices and was the pastor's home. The first pastor was Fr. Adelheim Odermatt, who later founded Mount Angel Abbey. (Courtesy of MAHS.)

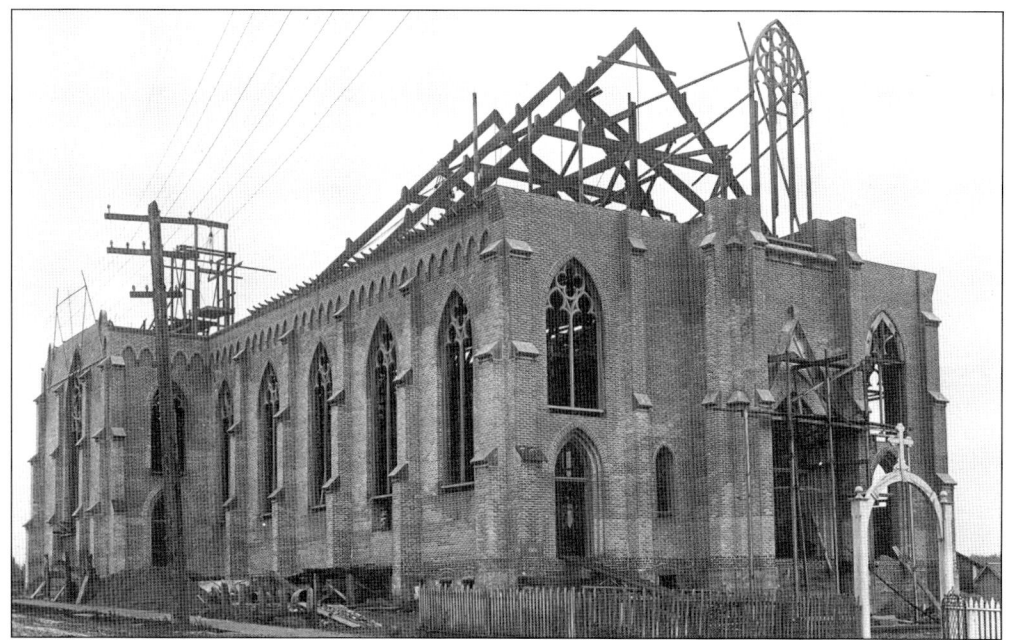

In 1908, the pastor of St. Mary's Church, Fr. Placidus Fuerst, asked the parishioners to consider building a new church. Engelbert Gier was selected as the architect and designed a Gothic Revival-style building. The cornerstone was laid in 1910, and the church was completed in 1912. (Courtesy of MAHS.)

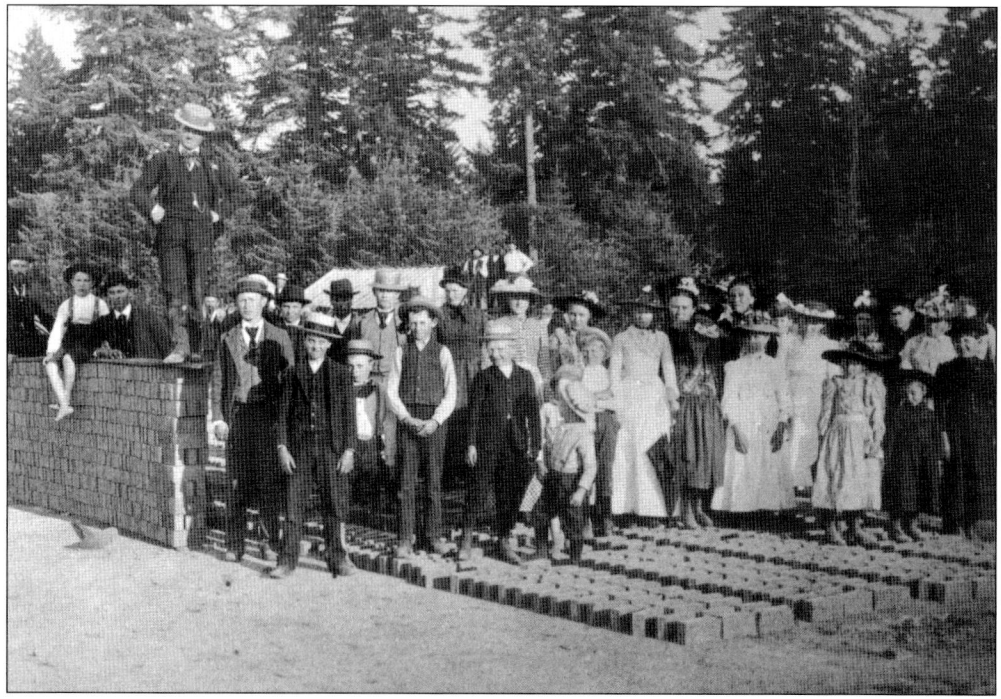

Since the new church was going to be made of cement and bricks, Fr. Placidus Fuerst sent Frank Wilke to Portland to learn how to make, cure, and waterproof bricks. Part of the congregation stands by the locally made bricks for the new church. (Courtesy of MAHS.)

The inside of St. Mary's includes altars partially carved by Emil Gier, the brother of architect Englebert Gier. Emil carved the two large Gothic shrines in the transept as well. The church has 22 stained-glass windows, four of which were imported from Germany. (Courtesy of MAHS.)

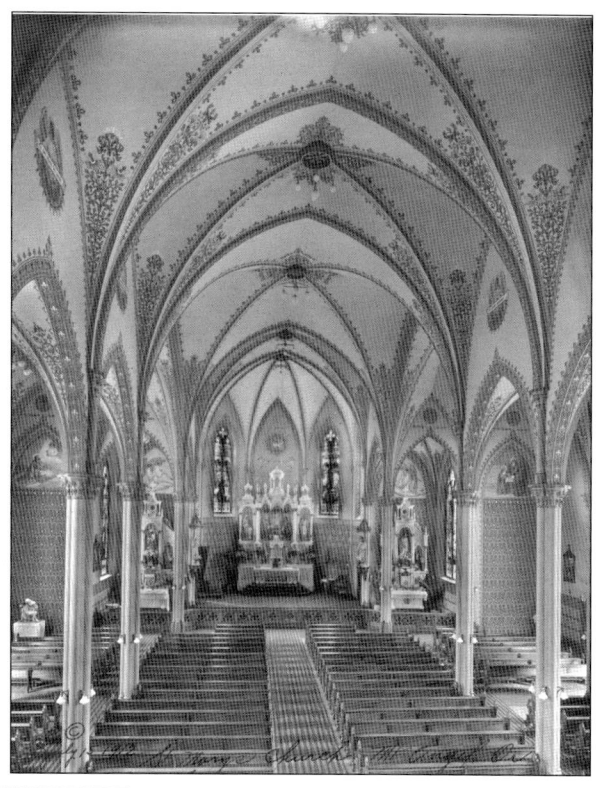

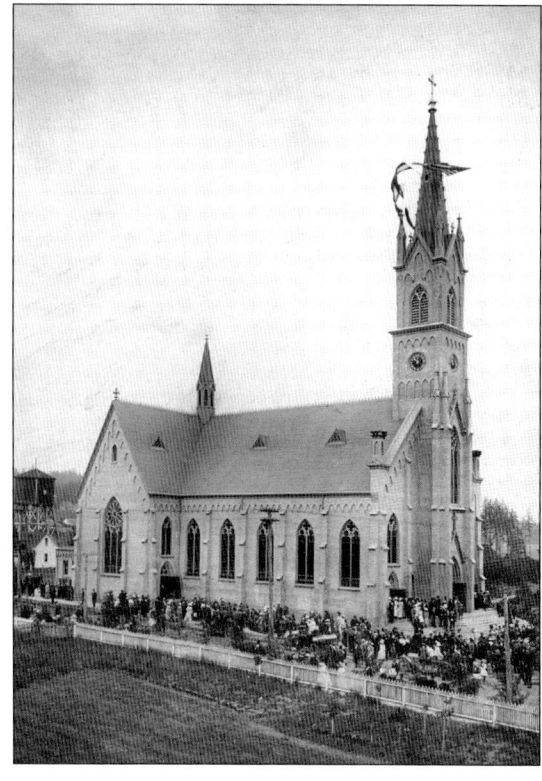

On June 30, 1912, hundreds of people came to the dedication of the new church. The Gothic building was 180 feet by 94 feet with a 200-foot church tower featuring an electric clock set to strike every quarter-hour. (Courtesy of MAHS.)

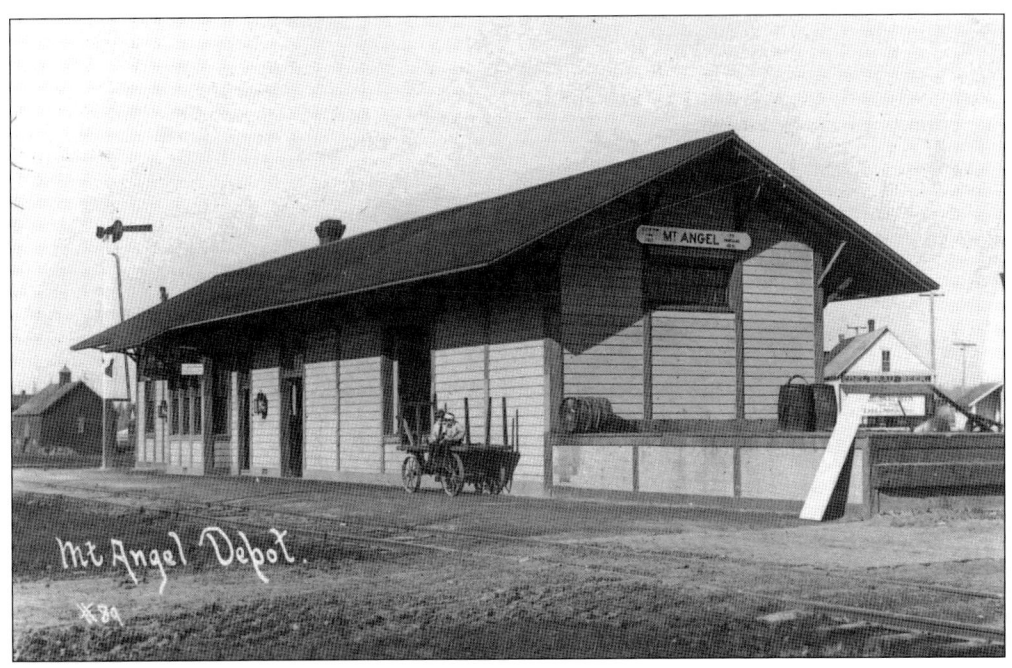

The Oregon Railway Company, the first business in Mt. Angel, completed its tracks in 1880 and built a little flag station. The rail had boxcars as well as passenger service, and Mt. Angel became a popular excursion for Portland residents on Sundays. The station grew from the depot building above to the busy depot below. In 1915, the town got two-way passenger service, with the trains running through local farms and stopping in Monitor and Mollala. Service was discontinued in Mt. Angel in the mid-1920s. While the track is still maintained, it is just for freight trains. (Both, courtesy of MAHS.)

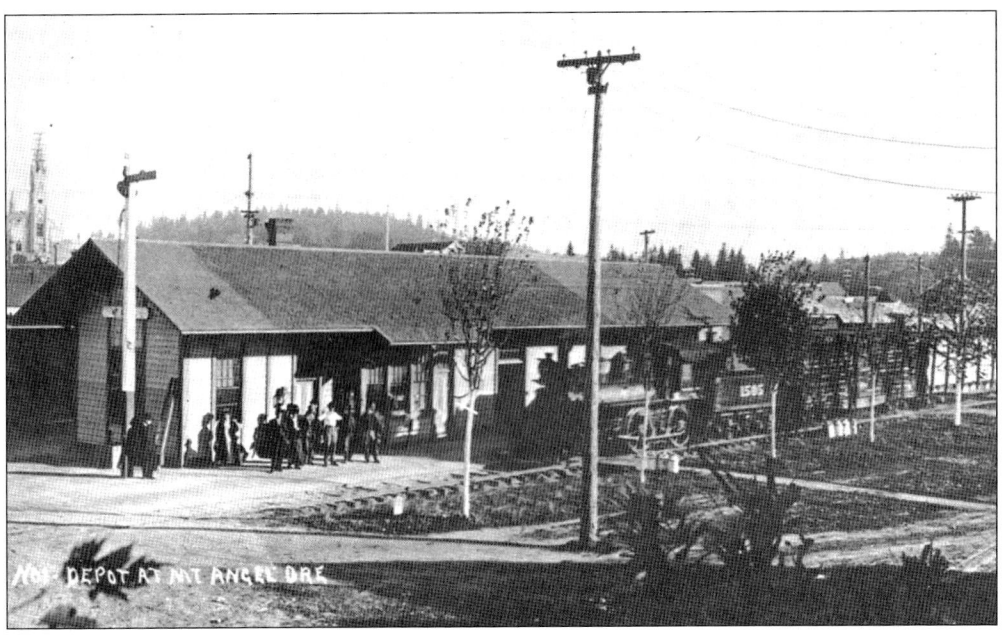

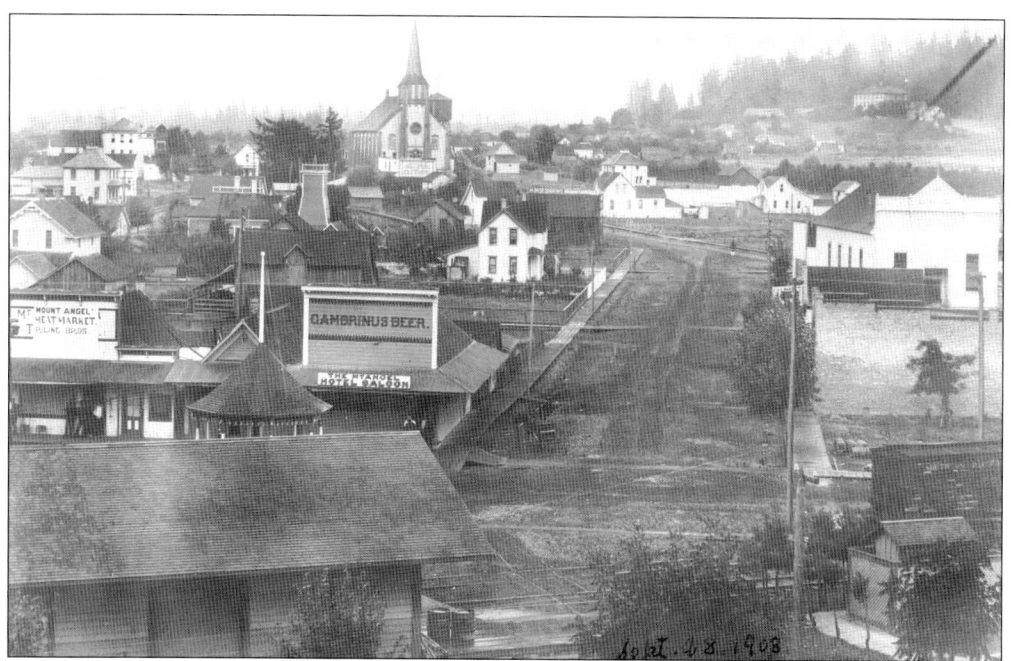

The above photograph was taken in 1903, just nine years before the photograph below. In the "before" image, there are still available lots and the Mt. Angel depot in the foreground had not yet been upgraded. By 1912, the new law mandating brick buildings had taken effect. The new bank (right) is across from the upgraded depot and the new two-story brick building behind Mt. Angel Hotel Saloon was Joseph and Gaphardt Ebner's business. (Below, photograph by Drake; both, courtesy of MAHS.)

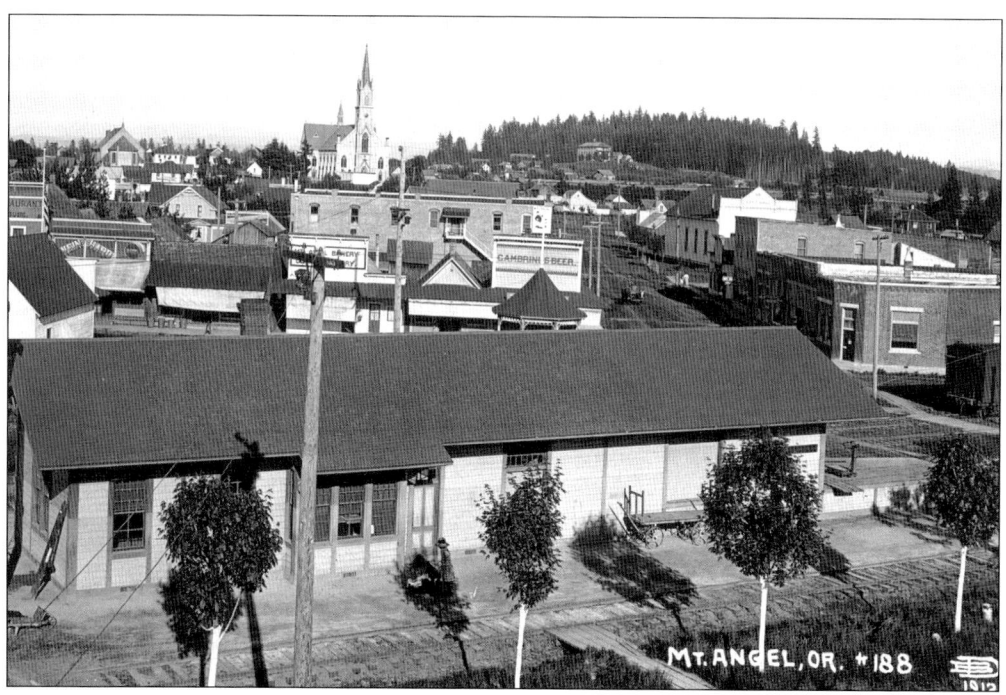

The Bank of Mt. Angel was started by J.M. Conklin and built in 1905 on a prominent corner lot deeded to it by the city, on the condition that it "carry out in a business-like manner the banking business in a brick building for two continuous years." (Courtesy of MAHS.)

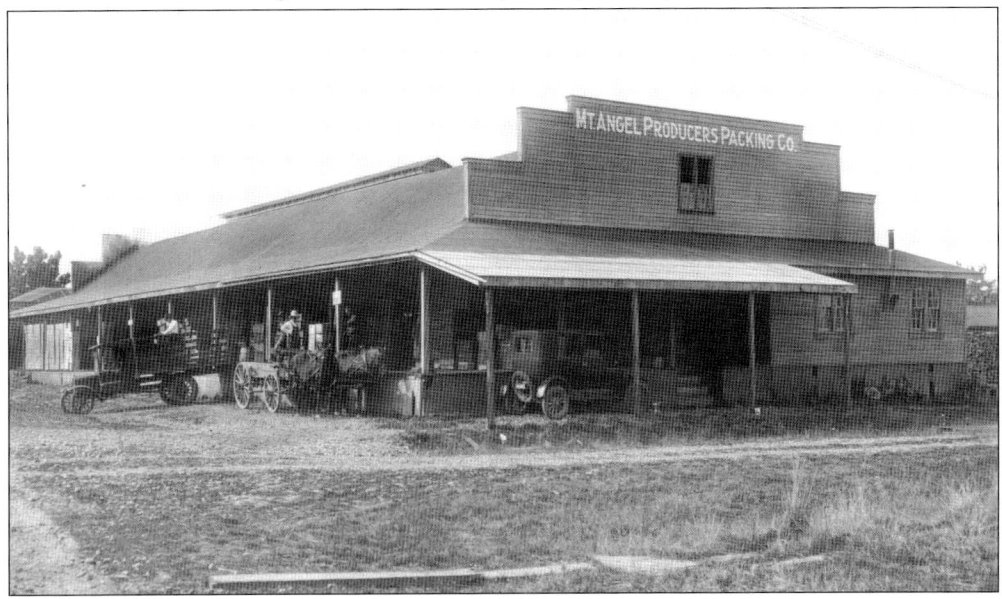

The Mt. Angel Producers Packing Company Cooperative canned both fruits and vegetables and shipped its products to England. In addition to being mayor from 1911 to 1913, George May was also the president of the company; its original stock sold for $25 a share. (Courtesy of MAHS.)

N. Schmaltz & Sons owned a warehouse and dealt in coal, wood, posts, drains, tile blocks, grain, and flour. Nicholas Schmaltz was born in the Ukraine in 1874 and came to Mt. Angel in the late 1800s. Since the business was so near the railroad, they were able to ship large cargo for their patrons. Because of their success in business, they were able to add to the original warehouse (above) and build a Shell gas station for the benefit of their customers (below). (Both, courtesy of MAHS.)

Opening in 1893, Joe Esch's blacksmith shop was essential to the farmers and tradesman of Mt. Angel. Esch made iron parts for farm equipment as well as carriage bolts, wagon wheels, and most importantly, the horseshoe. He also repaired harnesses. (Courtesy of MAHS.)

The Confectionery store is on the left in this 1912 photograph, next to Klinger's Saloon, which was established in 1898. Across the street is the Economy Store, owned by Pauline Hahn; Marion County Land & Investments, a real estate company owned by Paul Fuchs; and the Home Restaurant and Lodging House, owned by Jake Scharbach. (Courtesy of MAHS.)

Mount Angel Creamery and Ice Company, at Garfield Street and Church Road, became a stock-based company when the dairymen banded together in 1912. The creamery eventually had a fleet of 15 trucks and stayed in business until 1969. In this photograph are Charles Boxer (second from left), Fred Schwab (third from left), and Frank Heltweo (far right). (Courtesy of MAHS.)

Originally called the Marion Hotel, this became the Mt. Angel Hotel after the original hotel of that name on Railroad Avenue went out of business. Seattle native Leo Seifer was the manager. In 1914, the hotel was rated as one of the best-kept and popular hotels by Oregon state ratings. (Courtesy of MAHS.)

John Windishar's blacksmith shop was built in the center of town before 1905 and bought by Anton and Louis Weissenfels in 1919. Louis later became the sole proprietor, working until his retirement in 1979. The building is in the National Register of Historic Places. (Courtesy of MAHS.)

J. Siefer (left) poses with an unidentified man and two animals in front of his livery feed and sale stable on the west side of Main Street in the early 1900s. The livery stable was a necessary institution and provided transportation services as well. (Buchheit collection, courtesy of MAHS.)

This house, shown here in 1904, was originally owned by Thomas Howe, who established the Oregon Training Kennels behind the house in 1889. He brought pointers and setters from England and owned the first registered bird dogs in Oregon. Howe was also involved in the livery stable business, and his stagecoaches would meet the early trains in Mt. Angel. (Courtesy of MAHS.)

Marie Saalfeld sits behind the Henry Saalfeld Meat & Grocery in front of the current city hall. The original city hall on Main Street was moved to Garfield Street before burning in 1929, when this structure was built. Note the sign at the top of the building marking 1897, the year the first city hall was constructed. (Courtesy of MAHS.)

The White Corner store was built by David Back in 1900 on College Street and has housed many businesses over the years, including J. Jensen's new and secondhand furniture in 1915. It is now the White Corner Convenience Store. (Courtesy of MAHS.)

This aerial view to the west shows the White Corner building at the bottom of the photograph. Near the top are the Mt. Angel Hotel and the Mt. Angel train depot. While the photograph is identified as being taken in 1916, it may in fact be from the early 1920s. (Courtesy of MAHS.)

This view of Main Street shows, from left to right, the Bank of Mt. Angel; Jan's Bakery, the second floor of which housed Dr. Ralph Appleby's dental office; a confectionery store; and Terhaar Drug Co. (Courtesy of MAHS.)

J.W. Ebner stands in front of his hardware store, which sold groceries as well and was one of the first business ventures in town. Through the years, Ebner constructed more stores, and his last store building still stands. (Courtesy of MAHS.)

Terhaar Drug Co. was owned by the Terhaar brothers until 1924, when they sold it to William Worley, who renamed it Worley Drug and moved it to Main Street after 10 years. (Courtesy of MAHS.)

Buggies were used for transportation by local farmers as well as those living in town as they were cheap—as little as $25 to $50—and could be used by everyone. Above is an early business that produced and repaired wagon wheels and buggies. By 1910, automobiles surpassed buggies and companies like the Mt. Angel Motor Company were begun. A Ford agency and a garage were on Railroad Avenue in the early days of the automobile. The Ford agency eventually moved to Woodburn and became Hillyer Mid City Ford, and the garage is now run by the third generation of the Schmidt family as a 76 station. (Courtesy of MAHS.)

45

Bernard and Mary Oswald became the proprietors of the first Mt. Angel Hotel in 1883, when it was opposite the railroad station and had four rooms; guests were on the first floor and the family was on the second floor. The Oswalds eventually replaced it with a new, 11-room building before selling it to Jacob Berchtold in 1908. The hotel hosted the wedding dinner of Helen Ebner, J.W. Ebner's daughter, and J. Urban Schmitz. (Drake photograph, courtesy of MAHS.)

Three

BUSINESS AND INDUSTRY

The pioneers were blessed with land rich in timber, soil, water, and game. The land was capable of supporting the agricultural efforts of the early farmers. After the farmers were able to provide for their own needs, they created surplus. Surplus brought about the building of Mt. Angel. Early settlers George Settlemier and Benjamin Cleaver were willing to donate land and effort to build their town, and once town grid lines came into being, businesses started to flourish.

Small trade developed with community grocers in Salem, Gervais, and Portland. Since the roads were poor, the early settlers pursued a railroad line and depot in order to transport their hops and surplus crops of wheat, oats, and fruit. In 1887, the Southern Pacific Railroad took control of the narrow-gauge lines built by the Oregonian Railway Company Limited, constructing a small railroad station.

By the time of its incorporation, Mt. Angel had a population of about 250, a large grain warehouse that could handle 75,000 bushels, and a keg factory that supplied breweries in Salem, Portland, and Albany. Before the chamber of commerce, there was the Mt. Angel Commercial Club. In 1915, the officers included J.R Webb, president; Fred Schwab, vice president; P.S. Fuchs, secretary; and E.W. Barnum, treasurer.

Workers gather flax at a local farm. Early in the 1900s, flax was a major crop, used to create fabrics and oil for paints. It could also be used as medicine for inflammation, however, after World War II, demand dropped because of the introduction of synthetic fibers. (Courtesy of MAHS.)

Southern Pacific Railroad took over the rail line in 1887 and brought the track up to a standard gauge. For a time, there were four passenger trains daily and local crops were shipped out, but passenger service was discontinued in the 1920s. (Courtesy of MAHS.)

The inside of the Mt. Angel Train Depot had enough room for the two employees (unidentified) of the railroad to keep the scheduled business of the trains. The original depot had been named Fillmore for J.F. Fillmore, a director of the original railway, but the name was later changed to Mt. Angel Depot. (Courtesy of MAHS.)

William Grimm (second row, fifth from left) poses with a large group of farmers picking hops on a farm east of town on Boehmer Road. Hops, one of the staples of the Mt. Angel area, can be grown up to 25 feet tall and are used primarily to brew beer. (Courtesy of MAHS.)

Dr. R.Y. Watson began operating this drugstore on Railroad Avenue next to the Mt. Angel Hotel in the 1890s. In March 1894, he was elected as Mt. Angel's election clerk. (Courtesy of MAHS.)

The local shoe store and its cobbler, John Stecklein, were kept busy on Church Street. Stecklein was also active as the director of the Mt. Angel Band, started in 1884 by Edward Gooley, who had studied at Notre Dame. (Courtesy of MAHS.)

Reiling Meat Market on Main Street was originally owned by the Reiling brothers, seen here. Later, it was operated by Reiling and Helvey, proprietors, and called Mt. Angel Market. The proprietors advertised that they had the most up-to-date markets and cold storage plants in their part of the state. (Courtesy of MAHS.)

Antoinette Berning Klinger poses in Klinger's Millinery on Charles Street. Later, after Alfred Klinger relinquished ownership, it became Klinger & Bauman and carried a complete line of ladies and gentleman's furnishings and millinery. (Courtesy of MAHS.)

A Mr. Oberroeber (left) poses with his son in his store filled with two floors of case goods. The building was originally attached to a lumberyard and planing mill and was later called Killian-Smith before eventually housing a service station. (Courtesy of MAHS.)

Dr. James E. Webb, the mayor of Mt. Angel from 1922 to 1936, works in his office on Railroad Avenue. The banners on the office wall show his interest in the yearly Mt. Angel Horse Fair, at which he won several blue ribbons. (Courtesy of MAHS.)

Standing in front of a coffee display at the second Ebner Brothers general merchandise store are, from left to right, an unidentified woman, Veronica Ebner, Rose Ebner, Gaphart Ebner, and Joseph Ebner. After their business grew, they built this larger, brick store around 1910. (Courtesy of MAHS.)

J.W. Ebner (fifth from left) poses with customers in his last hardware store, built next to the Mt. Angel Bank and still standing today. The store offered hardware and farm implements, machinery, crockery, and seeds. Ebner also served as the president and director of the Bank of Mt. Angel. (Courtesy of MAHS.)

Joe Woelke was the proprietor of two barbershops in Mt. Angel. At that time, barbershops were local gathering places and most of the men of Mt. Angel had their hair cut and beards trimmed on a weekly or biweekly basis. (Buchheit collection, courtesy of MAHS.)

This is an interior view of the post office in the early 1900s. Monroe Cleaver was appointed postmaster in 1882, when the town was called Roy. The first post office was established in 1889 in the Palmer Store. (Courtesy of MAHS.)

The creamery business was started in 1889 by several farmers taking their excess milk and turning it into butter and cream. Here, George Meyer picks up milk from a supplier, hanging the can on a scale, weighing it, and recording the weight. (Courtesy of MAHS.)

Joe Esch stands in the center with two unidentified blacksmiths in his blacksmith shop, which was behind Klinger's Saloon on College Street from 1893 to 1905. (Courtesy of MAHS.)

The Mt. Angel Saloon building was owned by Mary Oswald, who also owned the Mt. Angel Hotel. From left to right are manager Jake Scharbach, Alex Scharbach, William Schnee, two unidentified men, and William Frank, who owned a dray and transfer company. Jake Scharbach was also the proprietor of the Home Restaurant. (Courtesy of MAHS.)

Alois Keber (left) poses with an unidentified man in the Bank of Mt. Angel. Keber joined the bank as a cashier in 1917. His brother Joseph Keber was in charge of the bank. When the Mt. Angel Bank became a branch of US National Portland in 1933, Joseph stayed until his retirement in 1949. (Courtesy of MAHS.)

Dr. Ralph O. Appleby tends to a dental patient in his office, which was above Jan's Bakery on Main Street for many years. Dr. Appleby was an active member of the community. (Courtesy of MAHS.)

Fred Schwab and Frank Stupfel owned the saloon on Main Street, later adding a new partner, Fred Hudson (left), posing here with Stupfel. (Buchheit collection, courtesy of MAHS.)

Fred Schwab was a commission merchant who dealt in hay, grain, and hops. He had many business interests in addition to being a farmer and the first mayor of Mt. Angel. Here, Paul Schwab (left) and Josephine Weis stand in front of one of his businesses. (Courtesy of MAHS.)

In 1924, William A. Worley purchased the Terhaar brothers drugstore, which had been on Main Street for many years. He renamed it Worley Drug Store and owned it for 42 years until his retirement. (Courtesy of MAHS.)

Henry Saalfeld and his daughter Helen stand in front of Henry Saalfeld Meat & Grocery. According to another daughter, Henrietta, her father started out as a farmer but did not like the farming life and around 1924 decided to start a grocery store. After school, the children helped out in the store, which he sold in the 1930s. (Courtesy of MAHS.)

On East Charles Street, next to the Windishar Building, stood the Shell gas station owned by T.B. Endres. Endres had several businesses and for many years not only sold gasoline, but repaired radios and electronic devices into the 1940s. (Courtesy of MAHS.)

A Mr. Koehler owned the Mt. Angel Cement Works on East Church Street in the same block where the creamery was later built. The cement company poured concrete blocks by hand. During that period of time the blocks were used for building, foundations, and for the farmer silos. The business was active in the 1900s. (Courtesy of MAHS.)

Monastery Mustard is a premium mustard produced and sold by the Benedictine Sisters of Mt. Angel. The secret recipe for the mustard was passed on for generations before being given to Sr. Terry Hall and her Benedictine community. Making the mustard are, from left to right, P. Laurie Hendricks, Sr. Alberta Dieker, Sr. Agatha Meissner, and Sr. Sara Feik. (Courtesy of QAMA.)

Four

SPIRIT OF FAITH

One of the most basic tenets of the community of Mt. Angel is its strong commitment to faith.

The earliest inhabitants of the area, the Kalapuya and Molalla tribes, climbed the butte, which was approximately 485 feet in altitude and incorporated approximately 800 acres, and built stone chairs to sit on and commune with the Great Spirit. They named the butte Tapalamaho, meaning "Mount of Communion."

As the white settlers came to the Oregon Territory, they brought their faiths with them. The first church in the area, a Presbyterian church, was erected in 1854 and led by Thomas Henderson Small.

Fred and Fredrica Schmelzer settled in Mt. Angel in 1878. Fredrica Schmelzer, a Lutheran, wrote to her former pastor in Wisconsin asking if it was possible to send a Lutheran pastor to serve a group of Lutherans in the community of Fillmore (Mt. Angel). The missionary sent, Rev. Edward Doering, was stationed in Portland but provided services to the small group until 1890, when the congregation formally organized as Trinity Evangelical Lutheran Church.

Sr. Mary Bernardine, who taught in the parochial school where Fr. Adelhelm Odermatt had been parish priest prior to his arrival in Oregon, was chosen to found the first convent of Benedictine Sisters in the Pacific Northwest. Over the last 130 years, they have built colleges for the community, taught at schools in Mt. Angel and the surrounding towns, opened a nursing facility for the elderly, and provided homes for refugees and the homeless.

Mathias Butsch, a Catholic, invited the Benedictine Fathers who were visiting Oregon to visit Fillmore. Because of the success of the visit, Father Odermatt was appointed pastor of Gervais, Fillmore, and Sublimity. Father Odermatt became Prior Abbot Odermatt, and from a small start in Gervais with 18 members, they built the foundations of Mount Angel Abbey. The monks at Mount Angel Abbey founded a college, built a seminary, and provided services and support to the local parish community.

The 30-foot-by-48-foot church was built on land donated by R.H. Barth and dedicated in June 1892. In the early 1900s, a church steeple and bell were added to the original church. The bell remains part of the current Trinity Lutheran Church. (Courtesy of TLC.)

Rev. G.E. Meyer was the first full-time pastor of the Trinity Lutheran Church, from 1890 to 1895. During this time, the congregation decided to build their first church. (Courtesy of TLC.)

Rev. J.A. Dachow, the pastor in 1898, also conducted services in a mission station in Salem, commuting by train. He is seen here with his wife and six of his 12 children. (Courtesy of TLC.)

The congregation wore their finery for the 1892 dedication of their first church, Trinity Lutheran. (Courtesy of TLC.)

Trinity Lutheran Church was surrounded by farms in the early 1900s. Congregants pictured here included, from left to right, Rev. Frederick Zehe, B. Schultze, A. Medack, W. Hug, H. Westenderf, and W. Homann. Pastor Zehe was given permission by his congregation to start conducting services in English in 1913 on the condition that it not interfere with the German services. (Courtesy of TLC.)

During the Second World War, the congregation banded together to build a brand new Trinity Lutheran Church. There were delays due to that time in history, but the congregation prevailed and the new church was started in 1948. The cornerstone of the church was laid in 1949. (Courtesy of TLC.)

In 1953, a beautiful pipe organ was removed from the Heathman Hotel in Portland and installed in Trinity Lutheran Church. Stained-glass windows were added to the church by various members in memory of their loved ones in 1964. (Courtesy of TLC.)

Sr. Mary Bernardine Wachter founded the first convent of Benedictine Sisters in the Pacific Northwest. As a young girl in Switzerland, she had entered the convent of Maria Rickenbach, agreeing to become a missionary to America in 1876 at the age of 21. (Courtesy QAMA.)

Mother Mary Bernardine was born in Isny, a city in Wuertemberg, Germany, which featured a Benedictine monastery dating from the 11th century. The monastery church was used by the Catholic congregation. It was in this old Benedictine church containing beautiful historical objects where Mother Bernardine was baptized and received her first Holy Communion. (Courtesy of QAMA.)

The Church of her Baptism and First Holy Communion.

The Benedictine Sisters started out in a former saloon in Gervais before moving to Mt. Angel in 1886 and building a convent. In 1889, the Benedictine convent was blessed by Archbishop William H. Gross with the name Queen of Angels Monastery. (Courtesy of QAMA.)

In 1902, a north wing was added to the monastery, and in the summer of 1912, the Queen of Angels Chapel was completed and dedicated. Here, the clergy stand on the roof of the first-story link to the academy, which was built next. (Courtesy of QAMA.)

69

In the lovely Queen of Angels Chapel, the sisters take time for reflection. Sr. Protasia Schindler, who joined the community in 1884, painted the *Assumption of Mary* in oil on canvas, and it was placed at the front of the chapel. Unfortunately, the chapel had to be razed after the 1993 earthquake in Mt. Angel. (Courtesy of QAMA.)

Shown here is Sr. Antionette Traeger, the first administrator of the Benedictine Village Home when it opened in January 1955 with 20 patients. Later, the patients were moved to the new Benedictine Nursing Home, which had 83 beds. (Courtesy of QAMA.)

The Benedictine Sisters provided healthy meals, including homemade bread they baked in the kitchen, for the people at the Benedictine Nursing Home. Here, Sr. Julia McGanty, who took her vows in 1949, takes loaves of bread out of the oven in 1958. (Courtesy of QAMA.)

71

Retired army colonel Harry Lambert arranged to care for 30 disabled Vietnamese children, but before the fall of Hanoi, he left with more than 100 children. Quick preparation was coordinated by the Benedictine Sisters, who took over the Oktoberfest beer hall, put up 70 cots, and arranged for the food and care of the children. (Courtesy of QAMA.)

From the 1930s to the 1950s, the Benedictine Sisters held summer retreats for women. In 1973, the retreat ministry was reestablished with the Shalom Prayer Center, which serves all faiths and cultures. Shown here are, from left to right, Sisters Mechtilde Fennimore, Eileen Kraemer, Loretta Bonn, Margaret Mary Johnson, Victoria Keber (by fern), and Therese Eberle (back right). (Courtesy of QAMA.)

In the image at right, Sr. Bernarda Duda drives the monastery's Toro lawn mower. Duda was the first sister to drive a convent car in 1936. While she enjoyed embroidery and arranging dried flowers, her great love was the land and she spent the majority of her years supervising and working the farm, garden, and orchards. She loved driving the tractor and doing the work herself. The orchard was her specialty; she planted trees and learned everything she could to grow them successfully. Below, she is on the ladder pruning trees in the orchard. (Courtesy of QAMA.)

The wood-fired fruit dryer was built in 1924 and is listed in the National Register of Historic Places. The wood furnace is fed a mixture of cedar and pine. The Sisters dried approximately 1,600 to 2,100 pounds of prunes each year, feeding the fires continually for about a week. (Courtesy of QAMA.)

To protect and shelter the Queen of Angels Monastery water source, a well house was built in 1908 in the Jacobean Revival style. The single-story structure has brick exterior walls, a gabled roof clad with metal tiles, and medieval label moldings over the window openings—all reflecting the style of that period. (Courtesy of QAMA.)

One of the reasons Fr. Adelhelm Odermatt chose the location for the monastery was that it resembled Switzerland's valleys, mountains, forests, and good farmland, and also featured the butte. From the time of St. Benedict to now, part of the fabric of the community is the responsibility for strong land stewardship and embracing sustainability in farming. Stated in a letter written by Father Odermatt in 1883 to Rev. Abbott Anselm Villiger of Odermatt's hometown of Engelberg, Switzerland, the community owned approximately 4,640 acres. Shown here is a conservatory at Mount Angel. (Courtesy of MAAA.)

Engleberg Abbey in Switzerland was founded in 1120 by Konrad Von Sellenburen. The French Revolution did great damage to it, and a 1729 fire required the church and monastery to rise from the ashes. In 1873, Abbot Anselm Villiger of Engleberg sent Fathers Frowin Conrad and Adelhelm Odermatt to found a monastery in America, and the Mount Angel Abbey was begun. (Courtesy of MAAA.)

Fr. Adelhelm Odermatt arrived in Oregon in 1881, serving as pastor in Gervais, Fillmore, and Sublimity while the abbey buildings around the butte were being constructed. He and his fellow monks moved from Gervais to the new abbey in 1884. (Courtesy of MAAA.)

The chapel on top of the butte is seen above in 1889. It was later expanded into the abbey chapel when the abbey was moved to the top of the butte. The abbey was originally built at the base of the butte because of the difficulty of getting water to the top. Below are the abbey, chapel, seminary, and college in 1888. The chapel was going to become the parish church and the local community had started a fund to expand the abbey church, but an 1892 fire destroyed the buildings and the abbey had to start all over. This also created the need for the parish to build a church in town in 1893. (Courtesy of MAAA.).

Above is the stone *Benedictine Press* building, completed in 1909. The *Press* was created in 1888 at the urging of Archbishop William H. Gross of Oregon City and was considered the largest private printing business on the Pacific Coast. During that time, the three major publications included *St. Joseph's Blatt*, a weekly paper, and *Mt. Angel Banner*—the student's magazine—and *Armen Seelen Freund*, both monthly publications. The publications had average readerships of 107,300 every month. Below, the presses are seen in action. Students could take courses in typesetting and printing. (Courtesy of MAAA.)

The cornerstone for another monastery was laid on June 21, 1899, by the archbishop of Oregon, Alexander Christie. In 1900, a cross was mounted to the top of the central tower of the new monastery, and it was occupied by 1903. (Courtesy of MAAA.)

In 1926, another devastating fire occurred and the monastery burned. The priests and seminary students were brought into town and placed with families so they could continue teaching and fundraising during the construction of a new monastery. It took 18 months before the monks could move back to the top of the butte and into the new monastery. (Courtesy of MAAA.)

This 1928 aerial view shows Mount Angel Abbey rebuilt and occupied. Since the fire, more additions have been made, including a retreat house and the world-famous Mount Angel Library designed by Finnish architect Alvar Aalto. (Tapia collection, courtesy of MAHS.)

Five

An Emphasis on Education

Lone Butte School District No. 41, encompassing present-day Mt. Angel, was officially recognized in 1856 by the superintendent of Marion County Schools. Mt. Angel was not the usual, small, Pacific Northwest town in the 1880s—the two colleges, the seminary, two high schools, and two elementary schools thrived mostly because of the Benedictines and their ability to offer exceptional educational opportunities.

In 1885, the Benedictine Sisters taught in the public school system, and by 1888, they had opened Mt. Angel Academy and Normal School on their convent grounds. In 1897, Mt. Angel Normal School was certified as a teacher training college for women. In 1947, the school's name was changed to Mt. Angel Women's College when it was accredited by the state to offer degrees in education and humanities. It was renamed again in 1958 when men were admitted, to Mt. Angel College.

The Benedictine Monks also offered educational opportunities for young men in religious studies and public schooling at Mount Angel College. A boy's high school was opened at the abbey in 1887, and one year later, a college was established, offering classical studies and commercial courses. To fulfill a need for theological studies in the Pacific Northwest, Mount Angel Seminary opened in 1899—the earliest American seminary west of the Rocky Mountains.

In 1902, Trinity Lutheran Church, located just east of town, offered a parochial elementary school, but it closed in 1928 due to low enrollment. In 1959, Mt. Angel Preparatory School, now John F. Kennedy High School, offered boys a Catholic high school education. It closed as a parochial school in 1969 and reopened one year later as a public school. In 1973, a four-year liberal arts college for Mexican American students opened. It was named Colegio Cesar Chavez, after the civil rights leader Cesar Chavez, who had rallied for the rights of Mexican farm workers during the 1960s. The college closed in 1983 due to a lack of funding and administration difficulties.

Mt. Angel's first public school is seen here in 1883. The Lone Butte School District No. 41 was reorganized in 1865 due to a substantial increase in students. At that time, land was donated by the settlers and three new schools—Milster, Hazel Dell, and Grassy Pond—were built to accommodate overcrowding. Teacher John Ambler (center) immigrated to Oregon in 1853. (Courtesy of MAHS.)

Hazel Dell School, with its 1915 class shown here, was constructed just south of town to ease overcrowding and enrolled an average of 46 students. (Courtesy of MAHS.)

Mount Angel Abbey's first college building was constructed in 1886–1887 just outside of town at the foot of the butte. (Courtesy of MAHS.)

The Benedictine Fathers established both a high school and a college in 1887 at the foot of Lone Butte. A Mount Angel Abbey classroom is seen here in 1900. (Courtesy of MAAA.)

St. Mary's School, located behind St. Mary's Catholic Church, is seen here in 1910, when the school enrolled 200 students. An advertisement written on the photograph says, "On the Road of a Thousand Wonders," promoting the Southern Pacific Railway line, which ran north from Los Angeles through the Willamette Valley to Portland from the late 1880s to the early 1900s. (Courtesy of MAHS.)

Trinity Lutheran Church, located east of Mt. Angel, offered a parochial grade school for its members. In this 1912 photograph, Pastor Frederick Zehe stands behind his students. (Courtesy of TLC.)

The Benedictine Sisters opened Mt. Angel Academy and Normal School in 1888, accepting female boarders as well as day students. The academy offered classes consistent with a high school education, and the normal school focused on preparing girls for the teaching profession. (Courtesy of MAHS.)

The 1902 Mt. Angel Academy Orchestra featured, in no particular order, violinists Grace Kronenbusch, Hazel Daniels, Kate Ketchum, Cecila Mann, and Maude Thompson; guitarists Bessie Berry, Edith Owen, Ruth Cleaver, Hazel Waling, Zuline Thibbits, Lillie Hassing, Anna Oswald, Laura Hayes, and Leonara Mess; mandolin players Sadie Settlemier, Ella Provost, and Florence Provost; and cellist Mary B. Scollard. The band was taught by Sr. M. Beatrice Fuerst, who is not pictured. (Courtesy of QAMA.)

As this poster states, the students at Mt. Angel Academy were studying mensuration, or geometry, taught by Sr. Anselma Feierabend (facing the camera at the back of the room) in 1908. (Courtesy of QAMA.)

Sr. Hildegard Waser, standing behind the girls on the left in 1909, taught the commercial classes for 18 years at Mt. Angel Academy. Typing, shorthand, business form letters, telegraphy, drawing, painting, music, and needlework were also taught at the academy. (Courtesy of QAMA.)

Mt. Angel Academy also offered college level science courses in this laboratory, seen here in the early 1900s. (Courtesy of QAMA.)

This 1925 photograph shows the Mount Angel Abbey complex. From left to right are the college, abbey, seminary, church, gymnasium, and sister's living quarters. In 1926, all the buildings except for the post office and the *Benedictine Press* office were destroyed by fire. After rebuilding in 1926, classes and living arrangements for the students were restructured. The abbey continued offering college and high school instruction but only provided boarding facilities for the seminarians. College studies continued until 1946, and high school instruction ended on the butte in 1959, when a new building, the Mt. Angel Preparatory School, was constructed in town. (Courtesy of MAAA.)

Howard Hall at Mt. Angel Academy and Normal School was designed and built in 1913 by Emil Schacht and Son. The building, on the convent grounds, housed the student's classrooms and dormitories and offered classes from primary grades up to high school. (Courtesy of QAMA.)

Students from the normal school pose on the steps of Howard Hall. The normal school offered teaching certificates and was accredited as a four-year college in 1959. (Drake Brothers photograph; courtesy of QAMA.)

St. Mary's School is seen here, just after it was built, in 1920. At this time, it was reorganized and changed from an all-Catholic school to a public one. (Courtesy of MAHS.)

Sr. Placid Casey is seen here with her first grade class at St. Mary's School. Sister Casey was one of the first sisters to begin teaching in the Lone Butte school district. (Le Doux photograph; courtesy of MAHS.)

Mary Holman and Lizzie Roth posed for this photograph at their eighth grade graduation, an important accomplishment for students in the early 1900s. Girls wore white dresses, and boys wore ties and a jacket. (Courtesy of TLC.)

Teresa Duda (first row, right) is seen in the early 1900s with her fellow eighth grade graduates, who all received a certificate from the Palmer Method of Business and Writing School. Teresa's parents, Frank and Julianna Duda, settled in Mt. Angel around 1893 and owned a small farm. (Kloft photograph; courtesy of MAHS.)

The Mount Angel College basketball team won the 1913 state basketball championship in the 145-pound division. Sponsored by the Young Men's Christian Association (YMCA), they beat the Jewish Boys Athletic Club 20-19. (Drake Brothers photograph; courtesy of MAHS.)

This mid-1920s photograph shows the boy's dormitory at Mount Angel Abbey's seminary and college, the second construction of the abbey buildings before an accidental fire destroyed them in 1926. (Courtesy of MAAS.)

The high school for boys moved into town in 1959 and was renamed the Mt. Angel Preparatory School. Due to decreasing enrollment and rising costs, the school reorganized in 1964 to offer coeducational instruction. After continuing concerns about enrollment, the high school closed in 1969, reopening in 1970 as the public John F. Kennedy High School. (Courtesy of Ron Graham.)

Sr. Augusta Raabe teaches a coeducational class on the geography of the holy land in the 1960s at Mt. Angel College. (Courtesy of QAMA.)

This is a recent photograph of the building used for Collegio Cesar Chavez—the first four-year, accredited institution in the West serving the educational needs of the Chicano community. On Main Street across from the Benedictine Sister's monastery, the main building housed the classrooms and the women's dormitory. Two outer buildings were used for art classes and housing for the groundskeeper. The college closed in 1983 and returned back to the Benedictine Sisters. The building currently houses St. Joseph's Shelter and the Mission Benedict, which provides food, clothing, housing, and advocacy services to people in need. (Courtesy of Ron Graham.)

Six

Celebrations and Entertainment

Community festivals and gatherings have been common in Mt. Angel since the early pioneers first settled around Lone Butte. Before 1900, entertainment consisted of school activities, family get-togethers, and church functions.

In 1883, Fr. Barnabas Held donated musical instruments when he heard a group of men were forming a band. Music became an important aspect of many gatherings when Edward Gooley took over as music director for the band.

In the early 1900s, people came from miles around to participate in festivals, which included a judging of show-quality horses, parades, and ball games. During the 1930s and 1940s, people from all over the state came to celebrate the annual Flax Festival in Mt. Angel. Beginning in 1936, a queen of Flaxiana, along with her court and escorts, were selected based on who sold the most tickets to the festival.

After World War II, there was a dramatic decline in the demand for flax when the military and businesses replaced flax with nylon products. The Flax Festival ended around 1950. In 1966, the City of Mt. Angel organized Oktoberfest to celebrate the fall harvest and represent the town's German and Swiss heritage. This annual celebration continues Mt. Angel's long-standing hospitality and welcomes visitors to share in a community-wide celebration.

The Mt. Angel Band plays at the home of Louis Schwab in the late 1890s. Ed Gooley, in front facing left, was the band's director from 1884 to about 1903. Gooley studied at Notre Dame and the Dana Musical Institute in Ohio before moving to Mt. Angel in 1883. (Courtesy of MAHS.)

The Mt. Angel Band poses for a photograph with Fr. Placidus Fuerst (center) in 1902. (Courtesy of MAHS.)

JUBILEE CONCERT 1935

GIVEN BY THE
MT. ANGEL BAND
JOHN STECKLEIN, Director

AUDITORIUM, Mt. Angel THURSDAY Dec. 13

CELEBRATING THE

FIFTIETH ANNIVERSARY

OF THE ORIGINATION OF THE MT. ANGEL BAND

The only band in the Valley with a record of a half-century of continuous existence

— PROGRAM —

1. Mt. Angel Band — — John Stecklein, Director
 - a. Grand March Roosevelt Father Dominic, O. S. B.
 - b. Victor Herbert's Favorites Victor Herbert

2. Address of Welcome — Father Alcuin Heibel, O. S. B.

3. Grieg Male Chorus — Dr. A. F. E. Schierbaum, Director
 - a. A Kjoere Vatten, A Kjoere Ve Rudolph Moller
 - b. Er Lebe Hoch .. Braun
 - c. Doan You Cry Ma Honey .. Bullard

4. Mt. Angel Orchestra — — Ed Gooley, Director
 (Mr. Gooley was organizer and director of first Mt. Angel band)
 - a. American Union Mackie - Beyer
 - b. Feast of Roses (Das Rosenfest) Munkelt

5. Jubilee Address — Father Placidus Fuerst, O. S. B.

6. Mt. Angel Band
 - a. Overture Patriotic .. Bowman
 - b. Song Of The Night .. Mackie - Beyer

7. Grieg Male Chorus
 - a. Home On The Range .. Riegger
 - b. Keep In The Middle Of The Road Bartholmew

8. Reminiscences — — — Father Maurus, O. S. B.

9. Mt. Angel Band
 - a. Beautiful Willamette Father Dominic, O. S. B.
 - b. Stars And Stripes .. Sousa

Star Spangled Banner

This is a program for the 50th anniversary celebration of the Mt. Angel Band in 1935. Many of the first band members were in attendance, including the first director of music, Edward Gooley. (Saalfeld photograph; courtesy of MAHS.)

This parade was sponsored by the Catholic Foresters of America in 1910. The organization was chartered in Mt. Angel in 1902 to raise funds in order to make available spiritual and social programs for its members. (Courtesy of MAHS.)

Young people line up in white in front of St. Mary's School for their first communion in 1901. (Weber photograph; courtesy of MAHS.)

This 1911 photograph of Mt. Angel's third annual horse fair provides a glimpse of Main Street in the early 1900s. A string of telephone poles were added a few years before this photograph was taken. The fair included ball games, picnics, music, and dances. (Weber photograph; courtesy of MAHS.)

Dr. James Webb frequently won first prize for his horses in the annual fairs. Here, he sits on the left, holding the buggy reins. (Weber photograph; courtesy of MAHS.)

Horse fairs in the early 1900s brought a variety of entertainment to town. In this photograph, most likely taken between 1910 and 1915, a crowd gathers to watch a horse pull masked participants on a turning wagon wheel. (Courtesy of MAHS.)

Handmade quilts, clothing items, and baked goods are displayed at this 1914 community fair. (Saalfeld photograph; courtesy of MAHS.)

A display set up at the 1926 Oregon State Fair portrayed important aspects of Mt. Angel. In the promotion in the foreground, the Mt. Angel Creamery and Ice Company says it will make 575,000 pounds of butter in 1926. (Courtesy of MAHS.)

Ice cream was a popular treat after summer baseball games in the early 1900s, when women's hats with wide brims and extravagant decorations were in fashion. (Courtesy of MAHS.)

The Ladies Sodality Club, seen here in 1913, encouraged women to participate in leisure activities, volunteer events, and religious services. (Courtesy of MAHS.)

The billiard hall in Mt. Angel was a popular place in the early 1900s for "pocket billiards," a leisure activity for working-class men. This building was located on Charles Street and is seen here prior to 1905. (Courtesy of MAHS.)

A group cools off in Abiqua Creek, just a couple of miles south of Mt. Angel, in 1912. (Seiler photograph; courtesy of MAHS.)

Some members of the Mt. Angel Band organized the St. Mary's Dramatic Club and gave performances at the city hall. They are seen here in 1912. (Courtesy of MAHS.)

This 1912 photograph at Schwab Field on Cleveland Street shows the Mt. Angel girls' baseball team, which was most likely organized by a city league. (Courtesy of MAHS.)

In 1936, the Flax Festival added a royal court with a queen, a king, and their escorts. Irene Berning and Al Haener were chosen as the 1936 king and queen to rule over the three-day event. Their float was sponsored by the Fred Schwab Commission Company. (Saalfeld photograph; courtesy of MAHS.)

This float was elaborately decorated with ribbons and flowers for an early-1900s Fourth of July parade. The wagon was parked in front of the Schwab house and sponsored by the Schwab and Zollner families. (Courtesy of MAHS.)

This August 1941 mailing promoted Mt. Angel's Flax Festival. (Courtesy of MAHS.)

This 1937 float was sponsored by the Mt. Angel Cooperative Creamery. The cooperative began operations in 1912 and had 2,500 members by 1948. Its featured product was the Rose Valley brand of cream and butter. In the 1960s, the cooperative closed and sold the Rose Valley name to the Farmer's Cooperative Creamery in McMinnville. (Courtesy of MAHS.)

This memorial was held by the city for the fallen men of World War II on April 23, 1943. (Courtesy of MAHS.)

Many church groups and social clubs set up booths during Oktoberfest to sell food and homemade items. In this 1970s photograph, two Benedictines Sisters make a fruit-filled bread for their booth at Oktoberfest. The Benedictine Sisters continue to sell pastries and many varieties of mustard at Oktoberfest. (Courtesy of QAMA.)

Since the first festival began in 1966, the Oktoberfest monument has been constructed each year by local artisans. It is located in the town square, and the produce, flowers, and grains making up the monument are all donated by local farms. Panels on each side of this 1970 monument represent the town and the themes designated for that year. The monument is always designed to be a symbol of the bounty and goodness of creation. (Saalfeld photograph; courtesy of MAHS.)

This panel from the 2011 Oktoberfest monument reads "Biergarten!" in honor of the opening of the new Festhalle, or festival hall, which sponsored many community events throughout the year. (Courtesy of Ron Graham.)

Built in 2006 with the help of local craftsmen, the Glockenspiel Tower resides in Mt. Angel's town square. Four times a day, the tower awakens to musical bells and dancing figurines portraying many notable people from the city's past. (Courtesy of Ron Graham.)

Seven
Faces of the Community

Mt. Angel was first organized as a town in 1893, when its 25 voters selected five councilmen to establish ordinances and bring about improvements for the new town. In 1905, with a population of 527, the Oregon State Legislature recognized Mt. Angel as a city. The previously elected president of the town's council, Fred Schwab, was then elected Mt. Angel's first mayor.

In 1910, the population for Mt. Angel was still about the same; however, according to election precincts, the population in the surrounding area had increased to 1,200. By 1920, Mt. Angel's population had almost doubled to 955, likely because of the two prominent colleges in town. Many people also moved into town between 1900 and 1930 to help with the construction of new college buildings, a new grade school, and a new Catholic church.

In 1936, a flax processing plant was built by the Works Progress Administration (WPA) in cooperation with the State of Oregon, attracting farm laborers to Mt. Angel. For the small farm owner, purchasing machinery was far too expensive, but hiring extra hands during the harvest season provided ready work for migrant and local workers. After World War II, the large-scale flax industry ended, along with the need for year-round farm labor. In the 1950s and 1960s, the small farms and businesses in the area relied on migrant workers to supplement local workers only for the fall harvest.

The primarily German and Swiss heritage of the town in the early 1900s slowly changed to reflect the diversity currently seen throughout the farming communities of the Willamette Valley. Mt. Angel's current population is just over 3,000, and it continues to be a close-knit community regardless of ethnicity and religion.

Engelbert and Rosa Gier married in 1883 and moved to Mt. Angel in 1906. Engelbert was the architect of the current St. Mary's Catholic Church, built in 1912, and worked in a family business with his brothers Emil and Henry building churches and altars and doing carpentry. (Homer photograph; courtesy of MAHS.)

Frank Wilke, seen here at age 22 in 1912, was sent by Fr. Placidus Fuerst to Portland to learn brick making for the construction of the new St. Mary's Catholic Church. (Courtesy of MAHS.)

Frank Fessler, seen here with his wife, Mary (Komp) Fessler, in 1901, was the son of Stephen Fessler and took over the operation of the family farm from his parents. (Saalfeld photograph; courtesy of MAHS.)

Henry and Elizabeth Saalfeld moved to Mt. Angel in 1909, initially owning a small farm outside of town. They sold the farm in 1923 and moved into town, operating Saalfeld Meat & Grocery on Charles Street until the 1930s. In 2010, their daughter Henrietta donated the family home to the City of Mt. Angel for use as a public park. (Saalfeld photograph; courtesy of MAHS.)

Emil Gier worked as a carpenter in the family business, building churches with his brother Engelbert. Emil specialized in carving altars and helped with the construction of St. Mary's Catholic Church in 1912. He also secured a patent in April 1914 for a stovepipe shield to protect surrounding walls from the extreme heat of a stovepipe. (Courtesy of MAHS.)

Jacob Berchtold stands with his son Joe at his legs in front of his hotel, the Hotel Mt. Angel, on Main Street in the early 1900s. (Courtesy of MAHS.)

Ludwig Bucheit and his family lived in the Mt. Angel area beginning in the early 1880s and grew hops on their family farm. (Courtesy of MAHS.)

Nicholas Schmaltz and his sons owned a general warehouse on South Main Street in the early 1900s, selling construction equipment such as cement, shingles, sand, gravel, and cement posts. (Courtesy of MAHS.)

John Schmaltz and his wife, Agnes, prepare to move this outbuilding in the early 1900s. (Schmaltz photograph; courtesy of MAHS.)

William and Mary Hug posed for this family photograph in the early 1900s with their children. The family included, from left to right, (first row) Minnie, Fred, William, Freda, Mary, and Ida; (second row) Elizabeth, Edward, and Emma. (Courtesy of MAHS.)

Fred Holman poses in front of the barn on his farm near Mt. Angel. (Courtesy of TLC.)

Paul Predeek and his wife, Mary (Junker), moved to Mt. Angel in 1900 and purchased 100 acres east of town. Paul died in 1910, and Mary continued working the farm with the help of her children. (Predeek photograph; courtesy of MAHS.)

In the mid-1920s, Mary Predeek (second from left) poses on the farm with four of her seven children. From left to right are Bertha, Mary, Sister Columbia, Marie, and Bernard. (Predeek photograph; courtesy of MAHS.)

Standing on the front porch of St. Mary's parish house in Mt. Angel are, from left to right, Father Ambrose, Fr. Dominic Waedenschwyler, and Fr. Frowin Epper. (Courtesy of MAHS.)

Joseph and Magdelena (Von Hatten) Stupfel lived in Mt. Angel in the early 1900s. Stupfel was partners with Fred Hudson in the Stupfel & Hudson General Store on Main Street in 1905. (Courtesy of MAHS.)

119

George May and his family are photographed in front of their family home in 1913. May owned a farm just outside of Mt. Angel and was mayor from 1911 to 1913. From left to right are (first row) Otillia May Zollner; George's wife, Therese (Komp) May; Sr. Claudia May; George May; and Marie May Donnelly. The rest are unidentified. (Courtesy of Sue Tapia.)

With the incorporation of the city in 1905, more services became available. A water tower was built, and the volunteer fire department was officially recognized. In 1906, new fire hoses and a cart were purchased and a fire brigade was created. The first volunteer members were Jacob Hessel, Paul Fuchs, Anton Poepping, Joseph Zollner, Lawrence Stupfel, and Capt. Gephart Ebner. Revenue to pay for these services came from saloon licenses and fees for renting the town hall. (Courtesy of MAHS.)

Charles and Catherine (Fessler) Schmidt were active in their church and community. Charles operated a saloon in the 1890s and was one of the first businessmen to apply for a liquor license in Mt. Angel. (Courtesy of MAHS.)

Anthony and Cecelia Skonetzni pose at their wedding in 1915. Anthony was a house painter, a volunteer with the fire department, and a member of St. Mary's musical band. Anthony and Cecelia also owned and operated the East End Grocery Store in Mt. Angel. (Peggy Stone photograph; courtesy of MAHS.)

George and Teresa (Faber) Wolleck arrived in Mt. Angel in the 1920s and owned a small farm on North Pershing Street. Posing for this family photograph are, from left to right, (first row) Teresa, Katherine, and George; (second row) Eva and Andrew. Katherine later worked at the Hotel Mt. Angel. (Guerrettaz photograph; courtesy of MAHS.)

Mathias and Suzanne Beyer and their children posed for this photograph at the Joseph Jenny Photography Studio in Mt. Angel around 1915. The family included, from left to right, (first row) Matilda "Till" Beyer, Mathias Beyer, Francis "Franz" Beyer, Bill Beyer, Suzanne Beyer, and Catherine Gagnon; (second row) Josephine Bochsler, Mary Scherzinger, Matt Beyer, John Beyer, Elizabeth Beyer, and Agnes Jeanette "Net" Beyer. (Sue Kloft photograph; courtesy of MAHS.)

Joseph and Rose Ebner and Gephart and Veronica Ebner stand in front of their store on Charles Street in 1910. (Courtesy of MAHS.)

Brothers Cletus (center) and John Butsch (right), grandsons of Mathias Butsch, pose with their friend Ben Weis (left) after the 21-year-old Cletus's acceptance into the Army in 1917. (Saafield photograph; courtesy of MAHS.)